WASHINGTON, D.C.
1861–1962

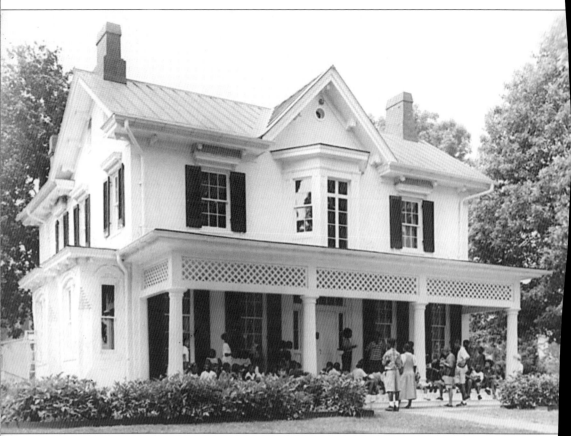

This stately home sits high atop a hill in Anacostia. Cedar Hill, distinguished as a National Historic Site in 1964, is the residence of abolitionist and statesman Frederick Douglass. He lived at Cedar Hill for more than 20 years in the late 19th century. Today the home still contains many of Douglass's personal effects, including original furnishings and artwork. Cedar Hill is part of the Anacostia historic district called Uniontown, organized in 1854. The District of Columbia Preservation League considers Cedar Hill, located at 1411 West Street in Southeast, as one of the most "endangered places" in the city. (Courtesy Library of Congress.)

ON THE FRONT COVER: The woman seen here reading is believed to be an associate or student of Nannie Helen Burroughs. The photograph was taken between 1890 and 1920 and is part of the Nannie Helen Burroughs Collection housed at the Library of Congress. In 1909, Burroughs, whose application to become a teacher was denied by the District of Columbia school board, opened her own vocational school in Lincoln Heights called the National Training School for Girls. (Courtesy Library of Congress.)

ON THE BACK COVER: In 1932, during the week of May 17–22, the National Association for the Advancement of Colored People (NAACP) convened the organization's 23rd conference in Washington, D.C. Notables who sat for this group photograph include NAACP staff Daisy Lampkin, Walter White, Mary White Ovington, Charles Hamilton Houston, Judge William Hastie, Roy Wilkins, and W. E. B. Dubois. (Courtesy Library of Congress.)

WASHINGTON, D.C.
1861–1962

Tracey Gold Bennett
Foreword by Catherine L. Hughes

ARCADIA
PUBLISHING

Published by Arcadia Publishing
Charleston SC, Chicago IL, Portsmouth NH, San Francisco CA

Printed in the United States of America

Library of Congress Catalog Card Number: 2006923700

For all general information contact Arcadia Publishing at:
Telephone 843-853-2070
Fax 843-853-0044
E-mail sales@arcadiapublishing.com
For customer service and orders:
Toll-Free 1-888-313-2665

Visit us on the Internet at www.arcadiapublishing.com

I dedicate this book to my mother, Dianne Williams Bennett,
in memory of my father, Alan Douglas Bennett,
grandparents Mildred and James Williams,
uncle Mitchell Williams, and to the city of Washington, D.C.

CONTENTS

ACKNOWLEDGMENTS

I could not have imagined the range of emotions I would experience while compiling material for Black America Series: *Washington, D.C.: 1861–1962*. The theme that continued to resonate with me as I researched and reviewed the images of slavery was the concept of choice. The enslaved ancestors that came before us did not have a choice about the fate that would befall them. Simple things we take for granted, choices about what garment to wear, what we're having for dinner this evening, what career we choose, where we live, the mate with whom we'll share our lives . . . imagine what it would be like to live in this world without options. Now we have the important responsibility to ensure that history is handed down, studied, and honored so that the mistakes of the past do not become the legacy of the future.

Therefore, first and foremost, I thank God for his guidance and protection. I honor the ancestors who came before us and who endured immeasurable pain so that future generations could enjoy an abundance of opportunities and a hopeful existence.

Next, I am very grateful to media giant, philanthropist, and community activist Catherine Liggins Hughes, founder of Radio One, for being a wonderful role model and for taking time from her schedule to write the foreword for this book. I also am thankful for the help of Coffi Bell, Catherine Hughes's assistant. Thank you to Arcadia Publishing, Jaquelin Pelzer, and Lauren Bobier for giving me this wonderful opportunity, and to my editor, Kathryn Korfonta, for holding my hand and shepherding the book through various stages. For resources contained in these pages, I thank the Library of Congress, Karen Blackman Mills and her wonderful staff at the Washingtoniana Division of the Martin Luther King Jr. Library, the Smithsonian Institution, the National Archives in College Park, Nizam Ali and Ben's Chili Bowl for providing photographs of one of the most important landmarks in the city, the folks at the Black Civil War Museum, the Alexandria Black History Museum, Valeria Henderson, and the rangers at the Fredrick Douglass House in Anacostia. I am grateful for the help of Ernest Hogan, who scanned several images for this book, and Lynn and Angela Doyle, who also helped me to secure photographs. Finally, I am humbled by the unwavering support of my family, my mentors Sabrina Dames and Curtis Crutchfield and many friends, including Faye Davenport and Robert White, who helped with this effort.

There but for the grace of God go I.

—John Bradford

FOREWORD

When I first moved to Washington, D.C., in 1971, I wrote home to my mother: "My eyeballs get fatigued each day from staring at the wondrous sights of black folks doing every imaginable thing under the sun and looking so very beautiful doing it." After 35 years of being blessed to call this city my home, my opinion has not changed one iota. This is the most incredible community of African Americans on the planet. Everyday the glorious history of what produced this community shines brightly through.

Starting with the first freed slaves who settled in the nation's capital, right through 1867, the year of the glorious history and legacy of Howard University, to the first elected mayor and city council, this city has always been a non-stop evolution of black progressive thoughts and actions. And yet I've witnessed a period when D.C. suffered under the highest murder rate in the nation. My heart has been broken at the sight of my elderly brothers and sisters sleeping on grates within a rock's throw of the U.S. Treasury, daily printing millions of dollars. I've experienced the self-imposed segregation of D.C.'s schools, neighborhoods, churches, and social events. I protested against the media's misrepresentation of D.C.'s local 70-percent-plus majority black population, and I have shared in the joys and triumphs of a community that is rarely exalted in the media unless the news is bad. I tried for nearly four decades to tell and broadcast the greatness of the Washington, D.C., story as it relates to a black perspective, and I've been blessed to build a viable business doing it.

I love this city because of the residents who call D.C. their home. I pray everyday that their numbers will not decrease to the point where African Americans are no longer the majority population. If that happened, I doubt that we could continue to produce the Frederick Douglasses and Mary McLeod Bethunes of the world.

—Catherine L. Hughes

INTRODUCTION

How did African Americans transition from the shackles of slavery to make significant contributions to the most powerful city in the world? Black America Series: *Washington, D.C.: 1861–1962* chronicles some of that journey. We begin with photographs representing the slave trade in neighboring Alexandria, Virginia, and tell the story of former slaves who joined forces with the Union to defeat the Confederacy.

Washington, D.C., is the nexus from which critical political decisions are made which radiate around the country and affect American's everyday lives and livelihood. As early as the 1860s, African Americans have been a part of the dialogue happening in the U.S. Congress. Not just a part of the dialogue but initiating the debate as members of the House of Representatives and the U.S. Senate.

History makers Frederick Douglass, Mary McLeod Bethune, Langston Hughes, Nannie Helen Burroughs, and Mary Church Terrell all lived in Washington, D.C., each having used their remarkable gifts and talents in a quest to improve the lives of African Americans. The images included in Black America Series: *Washington, D.C.: 1861–1962* include these prominent individuals and ordinary African Americans, some who lived in the city, but also those like Booker T. Washington, who used the city's institutional resources to change the stumbling blocks of racial discrimination into steps toward economic freedom for African Americans.

Inside the pages of this book are photographs of Washington's own sons and daughters of former slaves who have made contributions in the areas of politics, business, the military, medicine, education, religion, and the arts. Perhaps what is most interesting but often overlooked about the African American community in Washington is its diversity. Within the cloistered enclaves of Washington, D.C., are members of the black "aristocracy," some of the most affluent and influential African Americans in the country. Then of course is the middle class, which Howard University–educated sociologist E. Franklin Frazier chronicled in his 1957 book *Black Bourgeoisie*. And the very buildings in which this nation's leaders sat comfortably and created oppressive legislation were built on the backs of poor and working-class African Americans. In fact, history shows the U.S. Capitol and the White House were constructed using slave labor.

Exclusion and separation from the mainstream is a theme that characterizes the African American experience throughout the history of this country. Members of the U.S. armed services fought valiantly on behalf of their country but were segregated, were discriminated against, received less pay, and were subject to inferior conditions. Still they persevered.

Before integration, African Americans lived separately and created a booming business community in the U Street corridor known as "Black Broadway." Restaurants, theaters, a bank, and a casino were among the black-owned businesses that comprised Black Broadway.

Where African Americans were excluded, they created their own viable institutions. But the greatest legacy, I believe, created by the struggle of African Americans in Washington is an open door of opportunity for others. There is still much work to be done, but because of the foundation laid by African Americans in Washington, D.C., women, other ethnic groups, and the economically, socially, and politically disenfranchised now have the right of inclusion.

One

THE EARLY YEARS

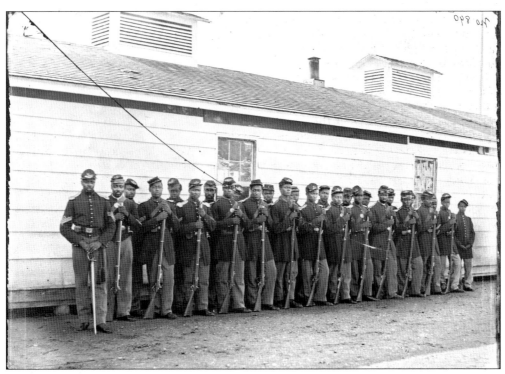

Many slaves escaped their circumstances and sought refuge in the ranks of the Union forces during the Civil War. In 1862, an act of Congress allowed African Americans to enlist in the Union army. Here 27 members of Company E, 4th U.S. Colored Infantry at Fort Lincoln are pictured in a photograph taken between 1862 and 1865. (Courtesy Library of Congress.)

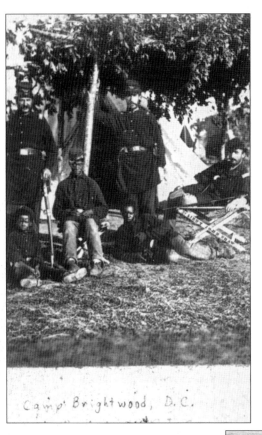

Camp Brightwood, D.C.

Slaves who ran away from plantations in the South were called "contraband." These refugee slaves were held in camps before they were utilized by Union forces. This photograph depicts one such camp in Washington, D.C., between 1861 and 1864. (Courtesy African American Civil War Museum.)

The person seen in this photograph is the Reverend H. M. Turner, chaplain of the First United States Colored Regiment. Born in South Carolina, Turner taught himself to read and learned to become a powerful orator by listening to and mimicking lawyers. An article in *Harpers Weekly* describes how a group of Abbeville lawyers were "impressed by his defiance." Reverend Turner used his spirit of defiance to recruit and organize "colored" soldiers. In April 1982, he became the pastor of Israel Baptist Church a position he used as a platform to deliver sermons on his recruitment efforts. The Reverend H. M. Turner was the very first colored chaplain to be commissioned in the United States military.

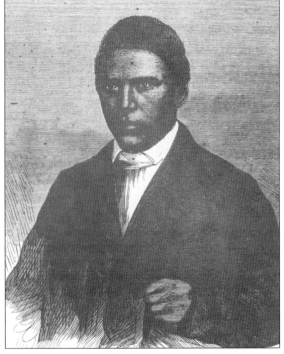

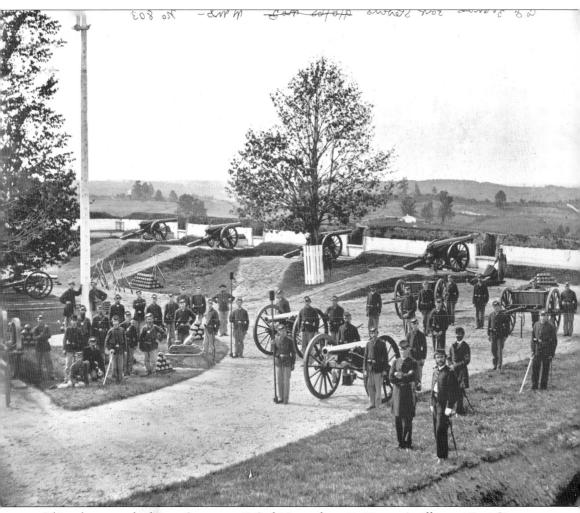

This photograph shows Company F, 3rd Massachusetts Heavy Artillery at Fort Stevens and was taken between 1862 and 1865. Elizabeth Thomas, a former slave, owned part of the land upon which Fort Stevens (Thirteenth and Quackenbos Streets, Northwest) was built in 1861. During a visit by Pres. Abraham Lincoln in 1964, Fort Stevens came under heavy attack by Confederate forces. (Courtesy Library of Congress.)

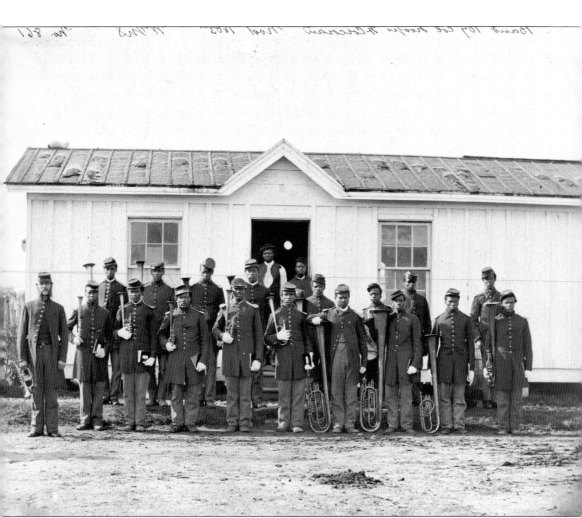

Twenty members of the 107th, U.S. Colored Infantry Band at Fort Corcoran in Arlington, Virginia, appear in this *c.* 1862–1865 photograph. African American troops earned half the salary of their white counterparts. More than 200,000 African Americans served in the Civil War; the majority of these African American regiments were comprised of slaves who gained freedom by participating in the war. (Courtesy Library of Congress.)

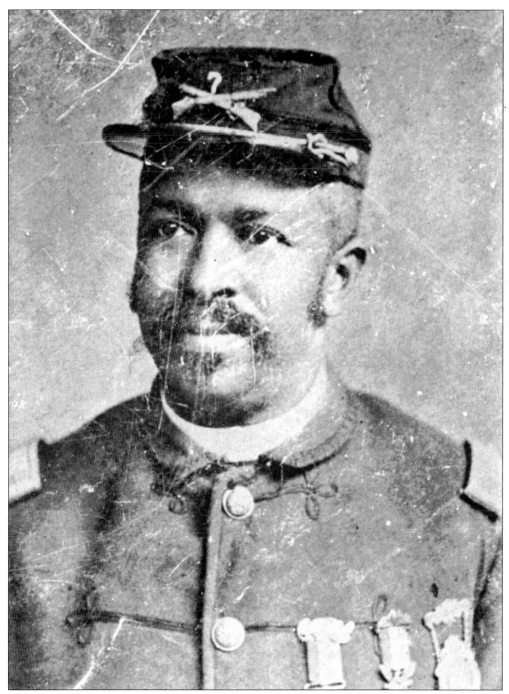

Congressional Medal of Honor recipient Sgt. Maj. Christian Fleetwood is pictured here in the early 20th century. Fleetwood was one of 21 African Americans who were awarded the distinguished Medal of Honor. When the war ended, Fleetwood organized a National Guard battalion in Washington, D.C. Fleetwood was also instrumental in forming the Colored High School Cadet Corps. Sergeant Major Fleetwood lived in a house on U Street in Northwest Washington with his wife, Sara. (Courtesy Library of Congress.)

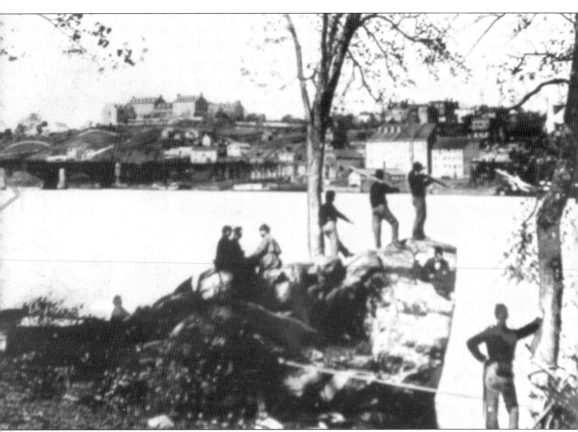

African American soldiers were housed and trained on Analostan Island during the Civil War *c.* 1861. The island, located along the George Washington Memorial Parkway, became Theodore Roosevelt Island and opened to the public in the mid-1930s. One of the island's main tourist attractions is a memorial to Pres. Theodore Roosevelt. (Courtesy African American Civil War Museum.)

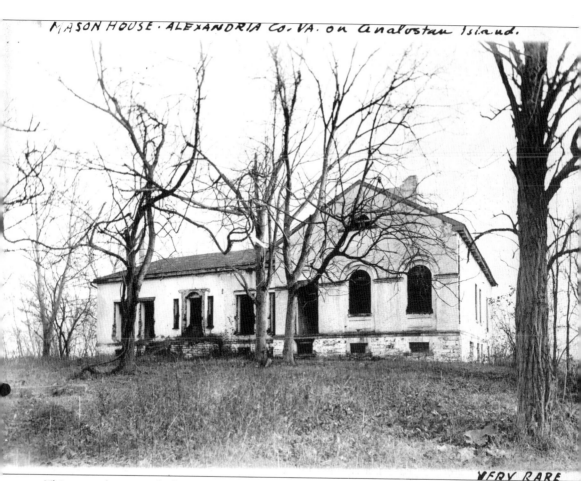

This rare photograph shows the house of Gen. John Mason on Analostan Island. General Mason's family owned the tract of land until 1834. Slave labor maintained the house and the island. African American regiments were trained on the island to protect them from the possibility of attack by those in favor of slavery who opposed black participation in the war. Some of the island's names throughout history include My Lord's Island, Mason Island, Analostan Island, and Theodore Roosevelt Island. (Courtesy African American Civil War Museum.)

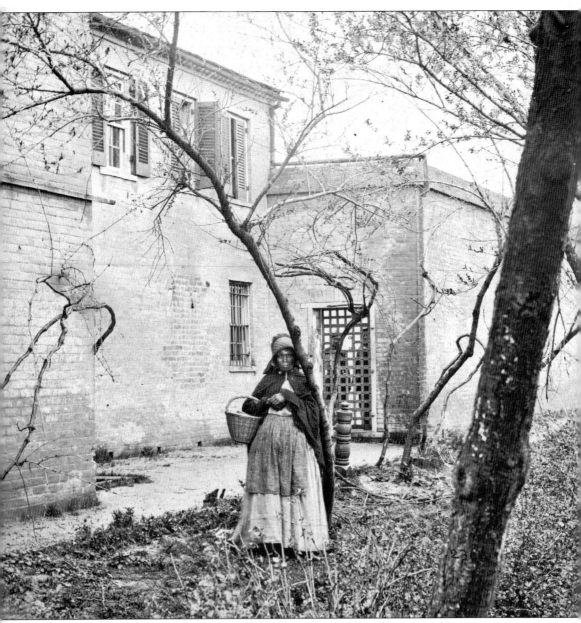

An African American woman, her face devoid of expression, stands in front of a holding pen for slaves in Alexandria, Virginia. When Union forces entered Alexandria, they shut down the slave-trading operation that owned this pen. The photograph is estimated to have been taken between 1861 and 1869. (Courtesy Library of Congress.)

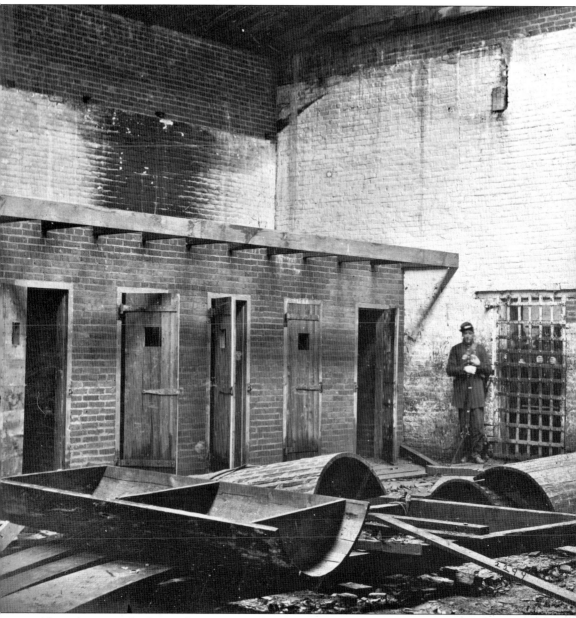

This photograph shows the interior of a slave pen located on the 1300 block of Duke Street in Alexandria, Virginia, *c.* 1860s. A soldier oversees the cells. (Courtesy Library of Congress.)

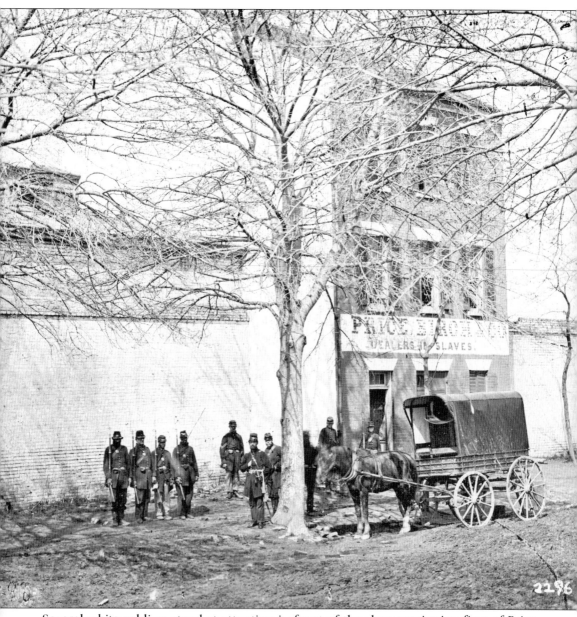

Several white soldiers stand at attention in front of the slave-auctioning firm of Price Birch and Company. The photograph was taken between 1861 and 1869. (Courtesy Library of Congress.)

This is an 1860s side view of an Alexandria, Virginia, pen where *Black* African Americans were held until they were sold. The average price for a child was $50, a woman could be purchased for $500 to $1,000, and the price for an African American man ranged between $1,000 and $1,800 dollars. (Courtesy Library of Congress.)

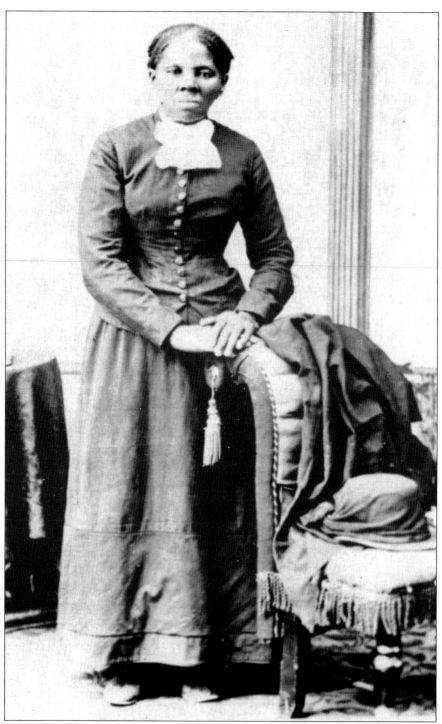

Harriet Tubman (1823–1918) escaped from a Maryland plantation and rescued more than 300 slaves from the bondage of slavery and led them to freedom via the Underground Railroad. She helped the Union army by serving as a spy. (Courtesy Library of Congress)

In 1818, Decatur House was built for white naval hero Steven Decatur. This historic house is located one block from the White House and contains one of the city's few remaining slave quarters. African Americans were bought and sold in Washington, D.C., until 1850. This photograph shows the southeastern view of Decatur House, *c.* 1937. (Courtesy Library of Congress.)

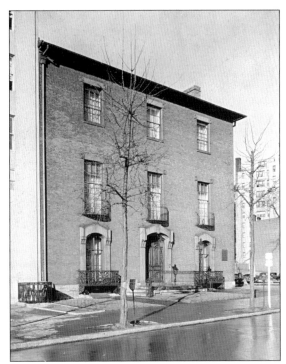

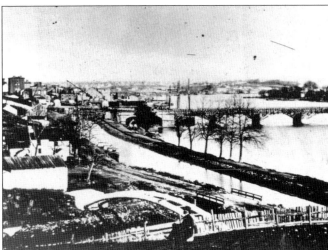

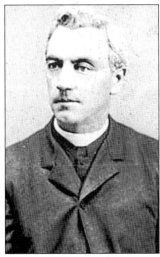

An unfinished U.S. Capitol can be seen in the background of this photograph of Georgetown taken in 1862. The image (above left) shows an overview of the C&O Canal aqueduct bridge. Following Emancipation, freed slaves settled in Georgetown, and some became prosperous, owning business in the area. Twelve years after this photograph was taken, Fr. Patrick Francis Healy (above right), became the first and only African American president of Georgetown University. Born in Georgia to Mary Eliza Healy, a mulatto slave, and Irish slave owner Michael Healy, the fair-complexioned Healy concealed his African American heritage. Healy, the first African American to earn a Ph.D., taught at Georgetown before becoming president of the Jesuit university in 1874. Healy Hall, a building constructed in the late 19th century on the campus of Georgetown University, is named in honor of Fr. Patrick Healy. (Courtesy National Archives.)

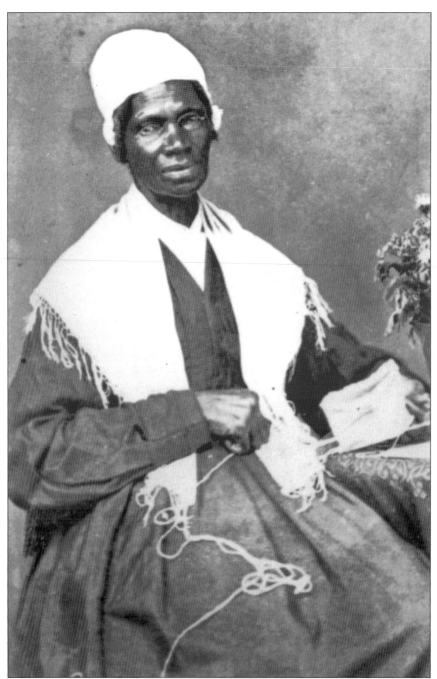

Sojourner Truth (born Isabella Baumfree) is depicted in this photograph. A historic meeting between Pres. Abraham Lincoln and Truth, an abolitionist, happened on October 19, 1864, at the White House. A significant character behind the scenes of the Civil War, Sojourner Truth actively recruited African American soldiers and supported those troops by providing supplies, including food and clothing. She is also credited with integrating the city's horse cars by convincing drivers to give her a ride. (Courtesy Library of Congress.)

Two

POLITICS

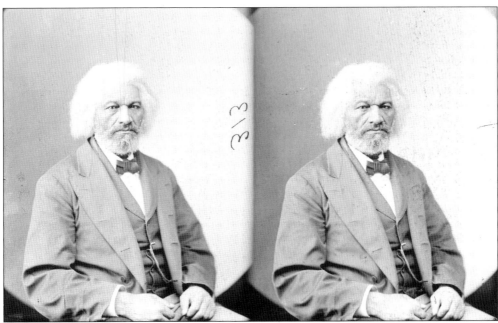

Abolitionist, author, and statesman Frederick Douglass was born a slave but became an agent of social change not just in Washington, D.C., but in the entire United States. From his humble beginnings on a plantation in Easton, Maryland, Douglass became an advisor to Abraham Lincoln. He encouraged a very reluctant President Lincoln to consider using African Americans to fight in the Civil War effort. Douglass held the position of recorder of deeds in Washington, D.C., and later consul general to Haiti. Consul general was the highest ranking government position ever held by an African American during that period. (Courtesy Library of Congress.)

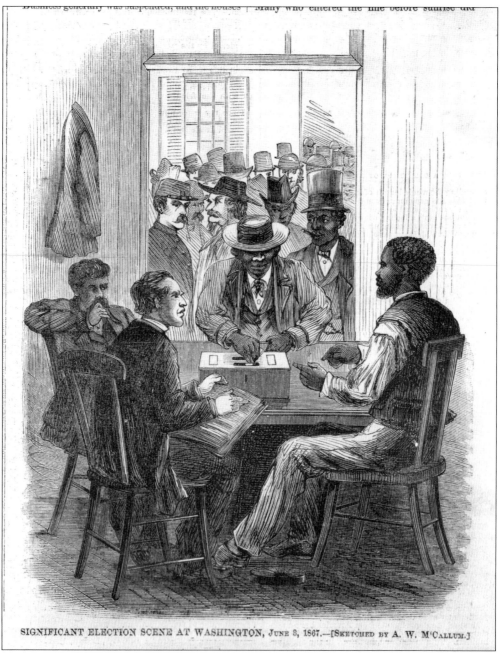

SIGNIFICANT ELECTION SCENE AT WASHINGTON, June 3, 1867.—[Sketched by A. W. McCallum.]

This artist rendering by A. W. McCallum depicts a black man and two white men observing while voters of both races stand in a line to cast their ballots during an election on June 3, 1867. Andrew Johnson was the president in 1867, and he began his term in 1865. McCallum's drawing illustrates what may have been a state election. In 1867, the state of Nebraska entered the Union. (Courtesy Library of Congress.)

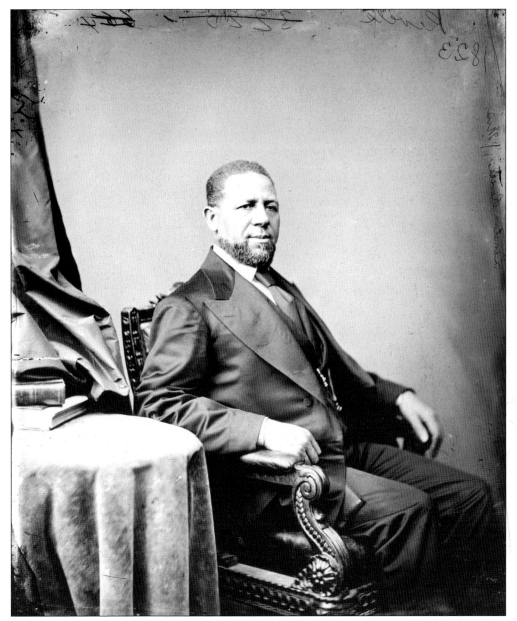

This portrait of the Honorable Hiram Rhoades Revels of Mississippi was taken between 1860 and 1875. In 1870, Revels, a Republican, was sworn in as the first African American senator. Revels, an educator and member of the clergy, organized African American troops in the Civil War and served as chaplain for those forces. Revels was a Mississippi state senator before being elected to the U.S. Senate. (Courtesy Library of Congress.)

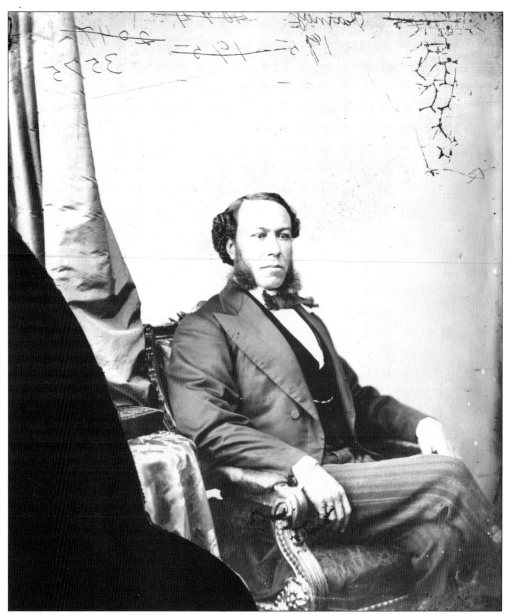

The Honorable Joseph Rainey, a Republican from South Carolina, sat for this photograph between the years of 1865 and 1880. In 1870, Joseph Rainey was sworn in to the House of Representatives. Rainey and Hiram Revels were the first African Americans to sit in Congress. Congressman Rainey served until 1879 and died in 1887 in Georgetown, South Carolina. (Courtesy Library of Congress.)

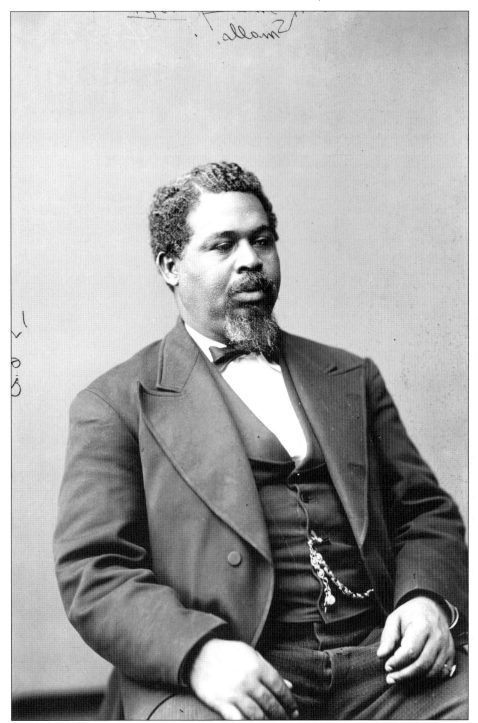

This photograph of the Honorable Robert Smalls of South Carolina was taken between 1875 and 1900. Smalls, a Civil War hero, escaped slavery in South Carolina by sailing a Confederate vessel into Union territory. In 1875, Smalls began serving his term as a member of the U.S. House of Representatives. (Courtesy Library of Congress.)

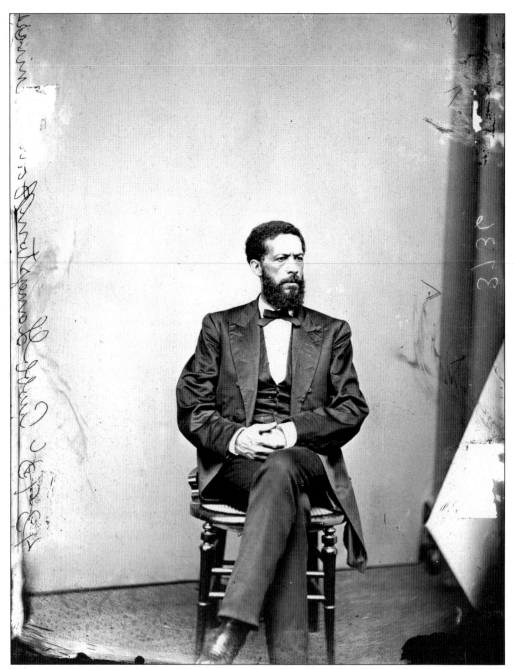

The first African American congressman from the state of Virginia was the Honorable John Langston, pictured *c.* 1860–1875. In 1873, John Langston, an employee of the Freedmen's Bureau, was selected as the dean of Howard University's law school. He later served in the House of Representatives. John Langston is buried at Woodlawn Cemetery, 4611 Benning Road, SE. Poet Langston Hughes was Congressman Langston's nephew. (Courtesy Library of Congress.)

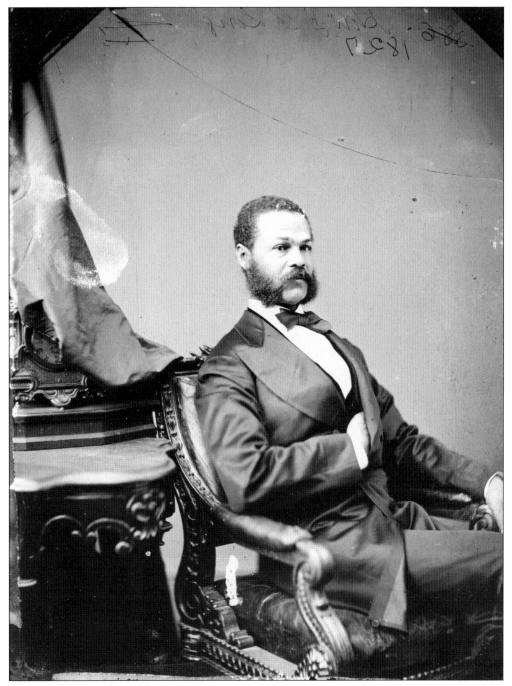

The Honorable Jefferson Franklin Long of Georgia sat for this portrait between the years of 1860 and 1875. Congressman Long, a former slave, represented the 4th District of Georgia in the U.S. House of Representatives from December 1870 to March 1871. He was the first black representative from the state of Georgia. (Courtesy Library of Congress.)

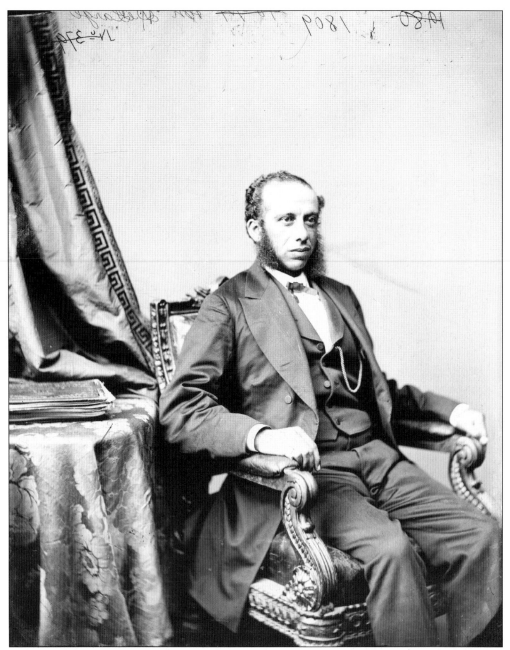

This photograph shows the Honorable Robert Carlos DeLarge, a Republican congressman from South Carolina, pictured *c.* 1860–1875. Congressman DeLarge served from 1871 until 1873, when a magistrate successfully contested the seat, which was later vacated. The following year, in 1874, DeLarge died in Charleston. (Courtesy Library of Congress.)

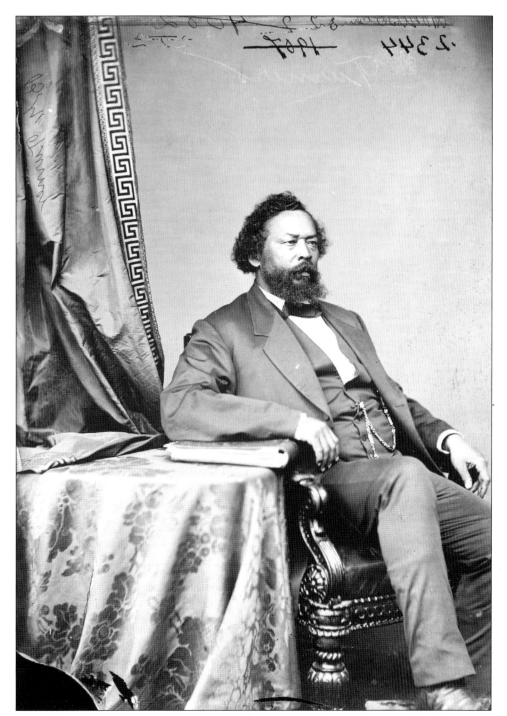

This portrait shows Benjamin S. Turner of Alabama, who was born a slave but rose to the position of U.S. Congressman after holding several municipal positions, including tax collector and city councilmember. This photograph was taken between 1860 and 1875. In 1871, Congressman Turner began serving in the U.S. Congress. He left office in 1773 and died in Selma, Alabama, in 1894. (Courtesy Library of Congress.)

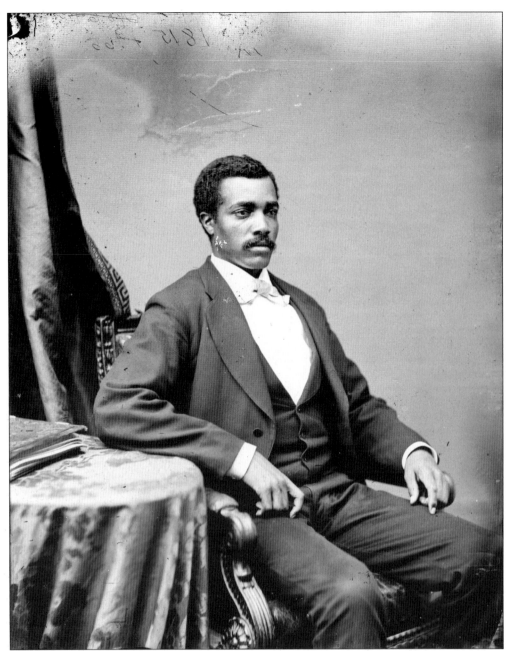

In 1870, Congressman Josiah Walls, a former slave, farmer, and Union soldier, was the first African American to represent the state of Florida in Congress. Walls supported a congressional bill that approved the land upon which Florida A&M University would be established. He is pictured here sometime between 1865 and 1880. (Courtesy Library of Congress.)

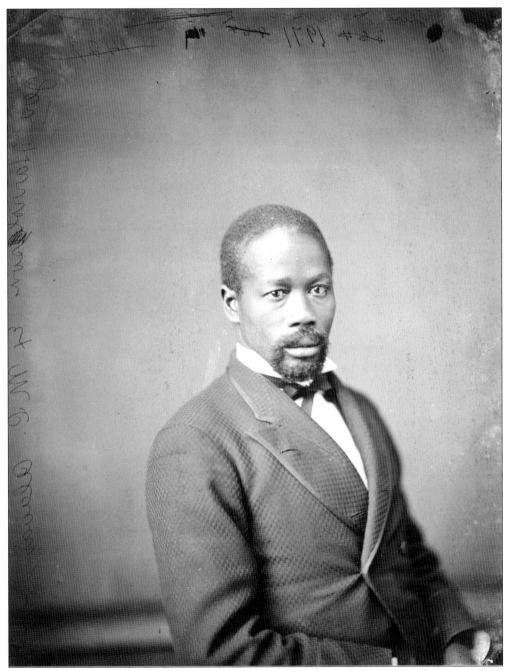

Congressman Jeremiah Haralson—a former slave representing Alabama in the 44th Congress from March 4, 1875, to March 3, 1877—sat for this portrait between 1865 and 1880. In 1882, following the end of his career in Congress, Haralson received an appointment to the Pension Bureau in Washington, D.C. (Courtesy Library of Congress.)

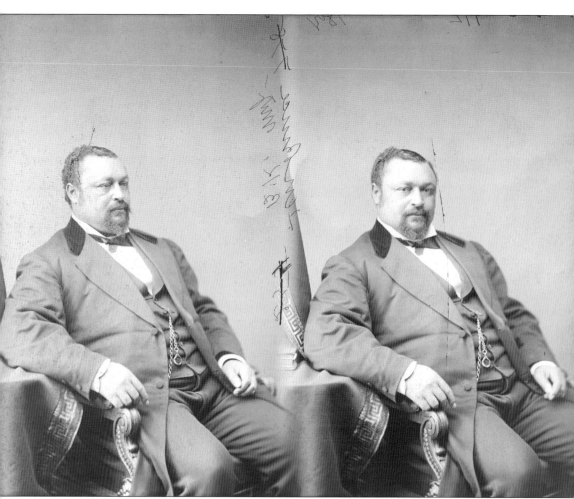

Sen. Blanche Kelso Bruce (a Republican from Mississippi), a former slave, was the second African American senator but the first to serve a full term. The photograph was taken between 1865 and 1880. In 1881, Pres. James Garfield appointed Senator Bruce to the position of register of the treasury. He died in Washington in 1898 and is buried at Woodlawn Cemetery, 4611 Benning Road, SE. The Blanche Kelso Bruce house is located at 909 M. Street NW. (Courtesy Library of Congress.)

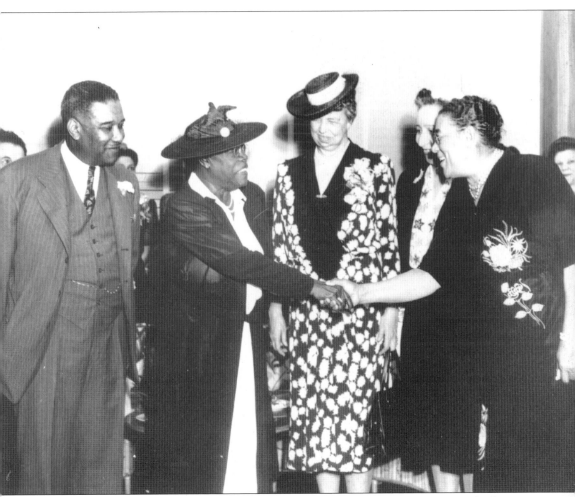

Mary McLeod Bethune (second from the left) founded the National Council of Negro Women and Bethune-Cookman College in Daytona Beach, Florida. A significant figure in Washington politics, her influence stretched as far as the nation's executive office. In this May 1943 photograph, Eleanor Roosevelt (second from the right) and others join Mary McLeod Bethune for the opening of Midway Hall. The hall was built by the government for African American civil service employees. As director of the Division of Negro Affairs of the National Youth Administration in the Roosevelt administration, Bethune was the highest-ranking African American woman official during her era. (Courtesy National Archives.)

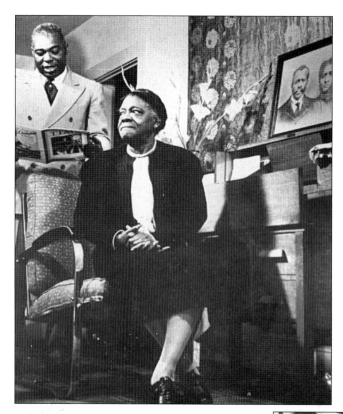

Bethune's last residence, 1318 Vermont Avenue, was also the original site for the National Council of Negro Women. That location is now known as Bethune Council House, a museum and national historic site featuring memorabilia from the remarkable woman who advised four American presidents. Mary McLeod Bethune is photographed here with an unidentified associate.

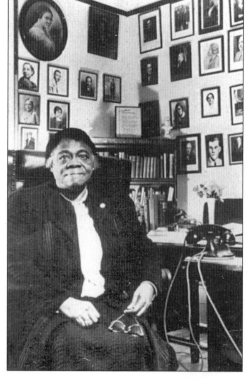

Pres. Franklin Delano Roosevelt's "Black Cabinet" advised him on social, political, and economic issues affecting the African American community during the era of the New Deal. Members of this select group of African Americans included Mary McLeod Bethune, the first African American to hold federal office (pictured at right); Judge William Hastie; Robert Weaver; Robert Vann; and Eugene Jones, among others.

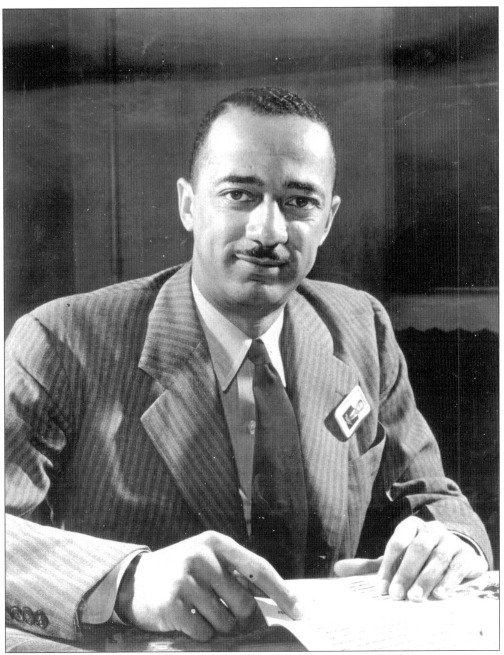

Judge William Hastie, dean of Howard University's law school, played a significant role in Franklin Delano Roosevelt's Black Cabinet by advising the military on minority issues. This photograph of Judge Hastie was taken in 1941, during his tenure as the civilian aide to the secretary of war, a position he resigned two years later because of the military's policies concerning African American service members. Hastie was the first African American federal judge. (Courtesy National Archives.)

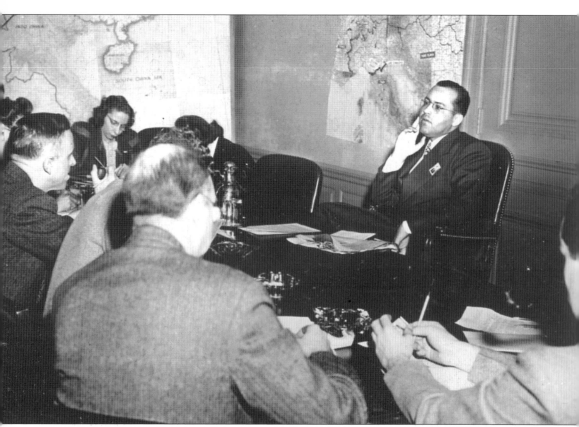

Truman K. Gibson, civilian aide to the secretary of war, is seen here attending a press conference on Monday, April 9, 1945. Gibson had just returned from the European theater of operations during World War II. He was next to hold the civilian-aide position following William Hastie. (Courtesy National Archives.)

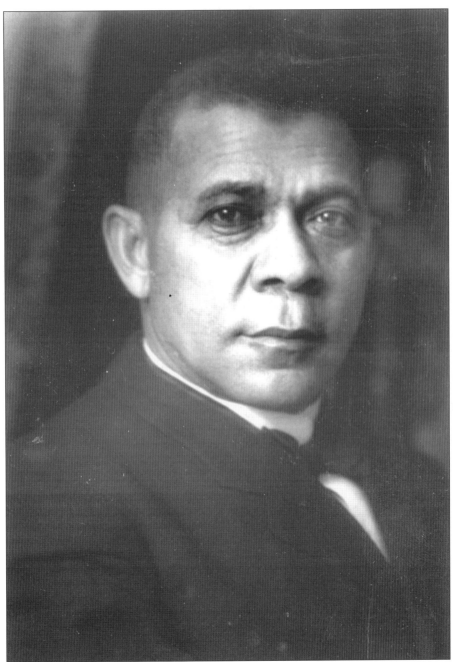

Educator, author, and political activist, Dr. Booker T. Washington encouraged African Americans to attain success through the concept of "self reliance." Though he was born a slave on a tobacco farm in Virginia, the lifelong Southerner would later command the attention and respect of the most powerful people in Washington and the United States. Presidents Theodore Roosevelt and William Taft routinely sought advice from Washington on matters concerning African Americans. In 1881, Washington founded Tuskegee Institute in Alabama. This portrait of Booker T. Washington was taken by Addison Scurlock *c.* 1910. (Courtesy Smithsonian Institution.)

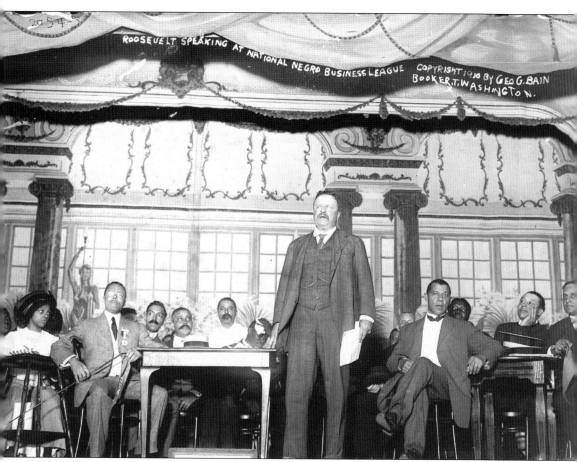

Pres. Theodore Roosevelt gives a speech to the Negro Business League in the early 20th century as Booker T. Washington and others listen in the background. Washington founded the Negro Business League in 1900. The goals of the organization were to promote and support African American entrepreneurship and to improve economic circumstances for blacks. In 1901, a dinner for Booker T. Washington and the National Business League was held at the White House. (Courtesy George Bain Collection, Library of Congress.)

W. E. B. Dubois, a sharp critic of Booker T. Washington, was the first African American to receive a doctoral degree from Harvard University. Dr. Dubois, a sociologist, author, and progressive thinker, was one of the founders of the NAACP. In 1907, he edited *The Horizon*, a magazine about race relations that was published in Washington, D.C. from 1907 to 1910. He later edited the NAACP's *Crisis* magazine. The first conference of Negro Land Grant Colleges was also organized by W. E. B Dubois. (Courtesy Smithsonian Institution.)

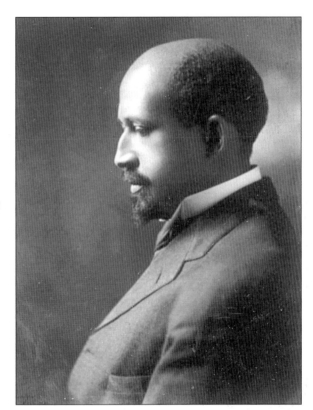

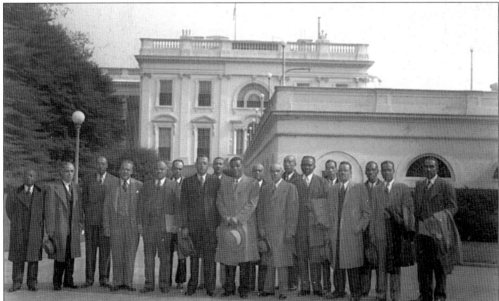

This photograph shows Land Grant College presidents posed with the White House in the background during the Truman administration *c.* 1946. Land Grant Colleges—which incorporate technical, agricultural, and military studies into their traditional curriculum—qualified for specific types of federal assistance. (Scurlock Studios; Courtesy Smithsonian Institution.)

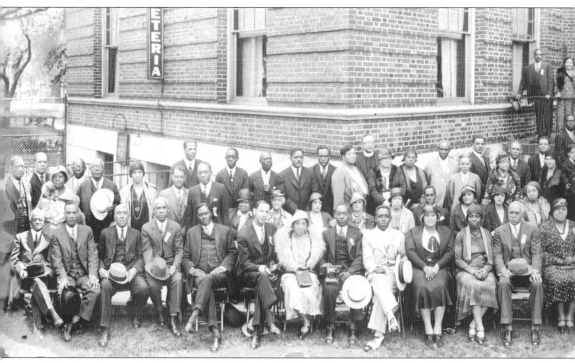

During the week of May 17, 1932, the National Association for the Advancement of Colored People held the organization's 23rd convention in Washington, D.C. NAACP staff members sitting in this photograph include Daisy Lampkin, Walter White, Mary

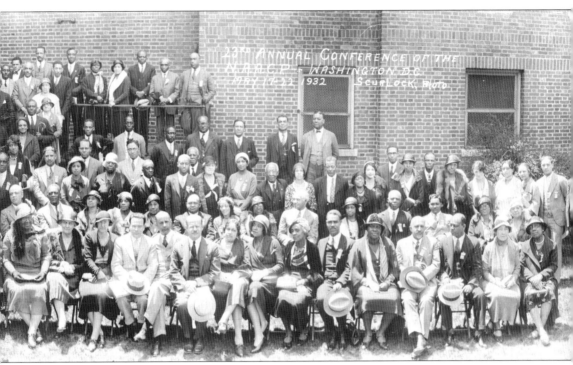

White Ovington, Charles Hamilton Houston, William Hastie, Roy Wilkins, and W. E. B. Dubois. (Courtesy Library of Congress.)

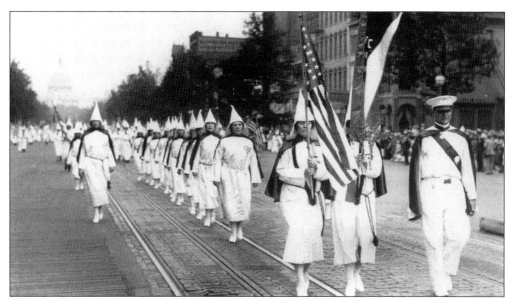

Members of the white supremacist group the Ku Klux Klan are shown here parading down Pennsylvania Avenue in the shadow of the U.S. Capitol in 1928. Nearly 20 years after this march, a member of congress, Sen. Theodore Bilbo of Mississippi, remained affiliated with Ku Klux Klan. His affiliation sparked public outrage, which resulted in a protest on August 9, 1946. Members of the Negro National Congress rallied against the vocal segregationist who sat on the Senate's District of Columbia committee. Bilbo's political career ended when the senate refused to seat him for another term in 1947. (Courtesy National Archives.)

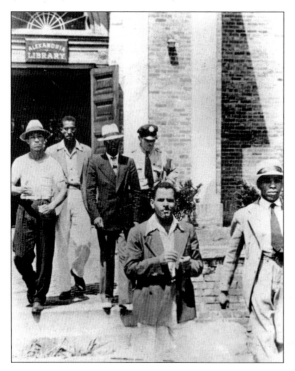

In 1939, the indignity of segregation moved five African American men in nearby Alexandria, Virginia, to stage a sit-in protest at the Alexandria Library. Led by attorney Samuel Wilbert Tucker, the group's goal was to secure library cards and to use the library that their tax dollars funded. After a librarian refused to grant the group's request for library cards, they quietly selected books from the library's shelves, sat down, and began reading; they were arrested for their actions. Appearing from left to right in this August 21, 1939, photograph the protesters are Williams Evans, Otto Tucker, Edward Gaddis, Morris Murray, and Robert Strange. (Courtesy Alexandria Black History Museum.)

Attorney Samuel Wilbert Tucker (1913–1990), a Howard University Graduate, successfully defended the young Alexandria Library protestors in court. Their actions led to the 1940 building of the Robert Robinson Library at 638 North Alfred Street in Alexandria, Virginia. The group's action did not immediately lead to the integration of the Alexandria Library at 717 Queen Street, where they protested, but the City of Alexandria's concession was to form a separate facility where Alexandria's "colored citizens" could have access to library materials. (Courtesy Alexandria Black History Museum.)

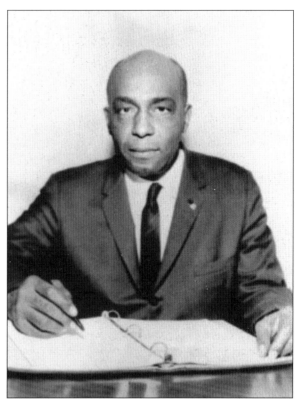

In 1967, President Lyndon Johnson appointed Walter Washington the first mayor commissioner of the District of Columbia. In 1975, after championing home rule, Washington would become the first mayor to be elected by the people of Washington, D.C. This portrait of Walter Washington was taken when he was student at Howard University Law School c. 1948. (Courtesy Scurlock Studios; Smithsonian Institution)

Civil rights activist and author Mary Church Terrell was born to former slaves in Memphis, Tennessee. Married to Judge Robert Terrell, she was the first African American woman to be appointed to the Washington, D.C., school board. A teacher at the M Street Preparatory School, Terrell was one of the charter members of the NAACP. Church Terrell also worked fervently on behalf of women's suffrage issues. This photograph of Mary Church Terrell was taken by Addison Scurlock around 1940. In May 1951, Mary Church Terrell would see the results of her activism when a Washington, D.C., court outlawed segregation in the city's restaurants. She died in Annapolis, Maryland, three years later in 1954. Mary Church Terrell and Judge Robert Terrell lived in Ledroit Park, next door to Paul Laurence Dunbar and his wife, Alice Ruth Moore. The Mary Church Terrell House, located at 326 T Street, NW, is a National Historic Landmark. (Courtesy Scurlock Studios; Smithsonian Institution.)

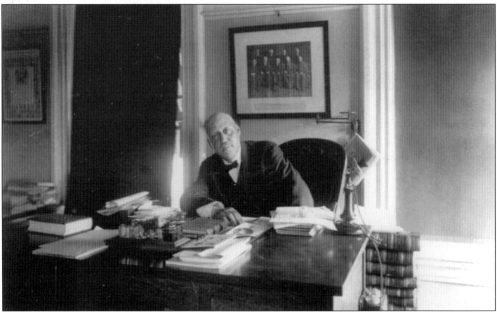

The first African American municipal court judge for the District of Columbia was Judge Robert Terrell (1857–1925). At one time, Robert Terrell was also principal of the M Street Preparatory School now known as Dunbar High School. (Scurlock Studios; Courtesy Smithsonian Institution.)

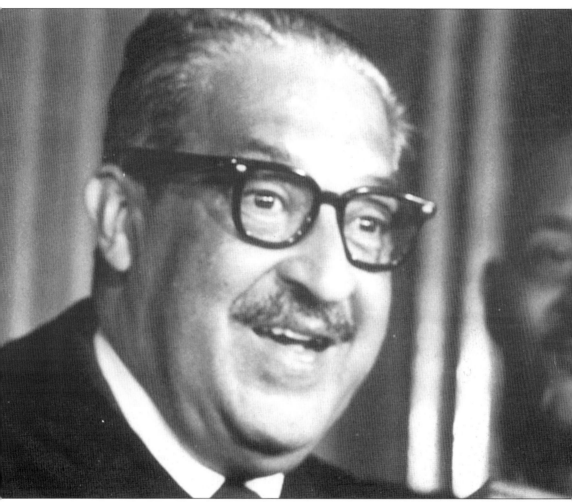

Supreme Court Justice Thurgood Marshall was the first African American to be appointed to the highest court in the nation. In 1933, Justice Marshall graduated from Howard University School of Law. Justice Marshall argued many civil rights cases, and as the head of the NAACP Legal Defense Fund, he was part of the legal team that convinced the high court that segregation in the nation's school system was unconstitutional (*Brown v. Board of Education*, 1954). (Courtesy the African American Museum and Library at Oakland Division of Oakland Public Library.)

This photograph shows three children attending an event on the lawn at the White House on April 2, 1923. The photograph was taken during Pres. Warren Harding's administration. President Harding died of a heart attack four months after this photograph was taken. His vice president, Calvin Coolidge, took office on August 3, 1923. (Courtesy Library of Congress.)

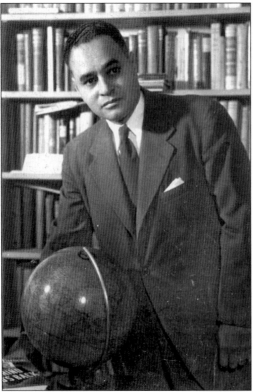

In 1949, diplomat, scholar, and author Dr. Ralph Bunche helped to negotiate peace in Palestine. The following year, Bunche, the undersecretary general of the United Nations became the first African American to receive the Nobel Peace Prize. (Scurlock Studios; Courtesy Smithsonian Institution.)

In the 1960s, the Honorable John Lewis, now a congressman from Georgia, was a leader on the front lines and a formidable force in the trenches of the civil rights movement. From freedom rides (the first freedom ride began in Washington, D.C., in 1961), to demonstrations, sit-ins, and voter registration campaigns, John Lewis often risked his life for the greater good. Perhaps one of the more poignant images of his spirit of determination was taken in 1965, when state authorities attacked John Lewis and 600 others who were demonstrating on the Edmund Pettus Bridge in Selma, Alabama.

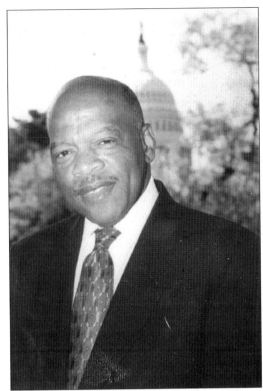

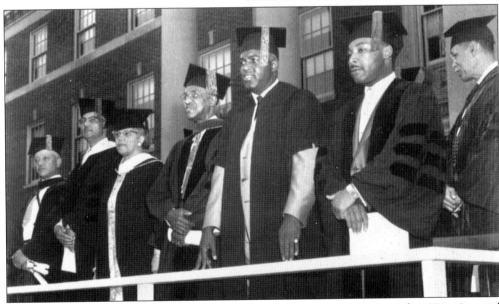

This photograph shows the preeminent civil rights leader Dr. Martin Luther King (second from right) and baseball legend Jackie Robinson (third from right) in academic dress participating in commencement exercises at Howard University. In 1957, Dr. King received an honorary Doctor of Laws degree from Howard University. In May, Dr. King delivered a speech at the Lincoln Memorial promoting voting rights. The event was called Prayer Pilgrimage for Freedom. (Scurlock Studios; Courtesy Smithsonian Institution.)

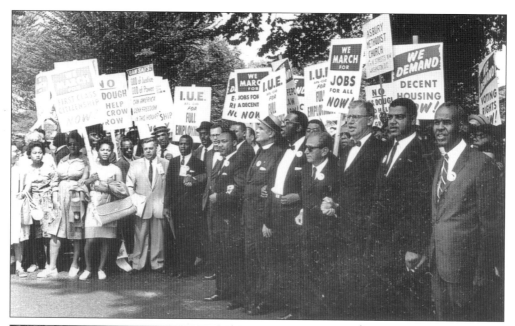

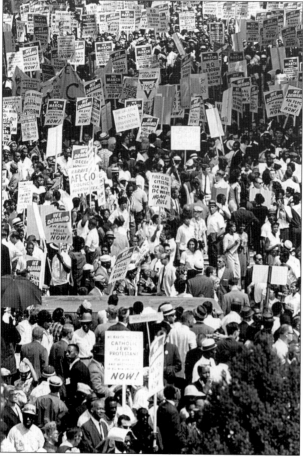

In 1962, organizers in Washington, D.C., helped Dr. Martin Luther King lay the foundation for this historic march on Washington in 1963. The protest focused on civil rights and employment for minorities. Dr. King is shown in the above photograph standing with a contingent of protestors who participated in the massive effort. A sea of protestors is depicted below. (Courtesy National Archives.)

Three

WASHINGTON INSTITUTIONS

Pictured here is Founders Library on the Howard University campus. In 1866, the groundwork was laid for an African American theological seminary, which would be called the Howard Normal and Theological Institute for the Education of Teachers and Preachers. In January 1867, that institution adopted the name of Howard University. Two months later, Congress approved a charter to incorporate Howard University. The university is named after Gen. Oliver O. Howard, a Civil War hero and founder of the university. In 1939, the Founders Library building on Howard University's campus opened its doors to the public. The library is called Founders in honor of the 17 men who founded Howard University. The Moorland Spingarn Research Center, the largest collection of African American historical material and artifacts in the world, is housed at Founders Library. Authors Toni Morrison and Zora Neale Hurston, thespians Debbie Allen, Phylicia Rashad, and Ossie Davis, New York's former mayor David Dinkins, and Dr. Camille Cosby are just some of the many notables who attended Howard University.

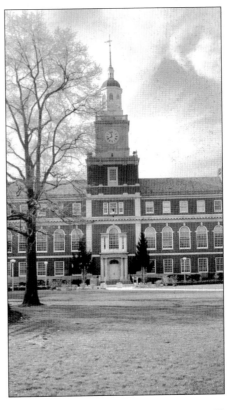

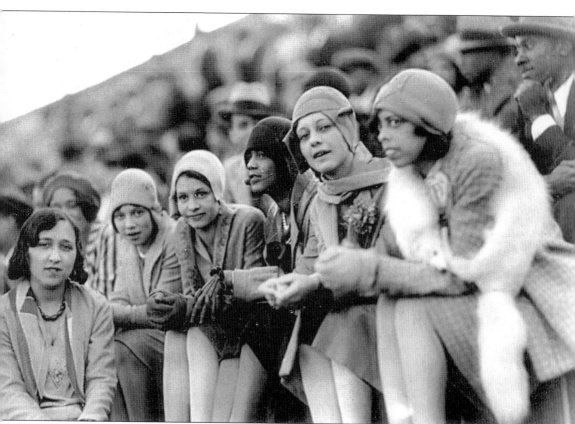

Six Howard University student "flappers" are seen here wearing hats at Griffith Stadium watching a sports event in the 1920s. Flappers were women who favored nontraditional dress. The National Stadium burned down, and when reconstructed in 1911, the ball park was named Griffith Stadium. For 50 years, Griffith was the home of the Washington Senators baseball team and the Homestead Grays, D.C.'s Negro League baseball team. (Scurlock Studios; Courtesy Smithsonian Institution.)

Addison Scurlock was one of the most sought-after photographers in the city. His subjects comprised the upper echelon of African American society. Scurlock Studios was the primary studio members of society hired to take wedding photographs. Several of the images in this book are from Scurlock Studios. Addison Scurlock's artful and prolific photographs tell a story about African Americans in Washington, D.C., that was not often told by others. Scurlock, with sons George and Robert Scurlock, chronicled the legacy of those described by author E. Franklin Frazier as the "Black Bourgeoisie" or perhaps even described by the more controversial term coined by W. E. B. Dubois—"The Talented Tenth." The subject of this photograph is Addison Scurlock and his wife, Maime Scurlock. The Scurlocks lived on T Street; their photography studio was nearby on U Street. (Scurlock Studios; Courtesy Smithsonian Institution.)

This 1940 photograph shows Dr. C. E. Brason, his new bride, and their wedding party. The following year on December 7, 1941, Pearl Harbor was bombed. Back in Washington, labor organizer A. Philip Randolph laid the foundation for a March on Washington to protest minority exclusion from Defense based contracts. This "March for Jobs" did not materialize, however, a committee to ensure fair employment practices in the government was established

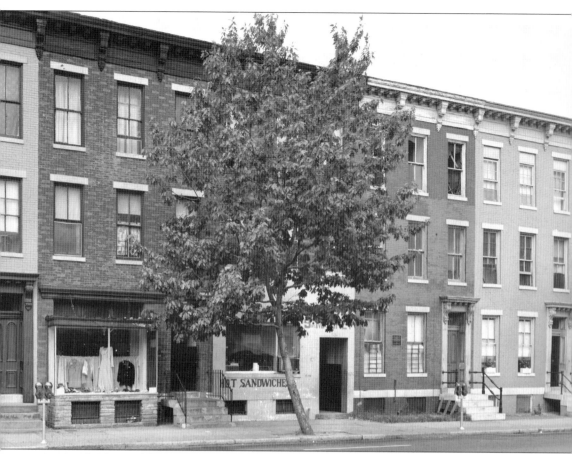

Harvard-educated historian Dr. Carter G. Woodson arrived in Washington, D.C., in 1909 and lived in this house on 1538 Ninth Street in Northwest Washington. He educated students at the elite Dunbar High School (then M Street Preparatory School) and is the founder of Black History Month. He is credited as being the patriarch of African American history. For a short stint, poet Langston Hughes worked as a clerical assistant for Dr. Woodson. This photograph was taken after 1933. (Courtesy Library of Congress.)

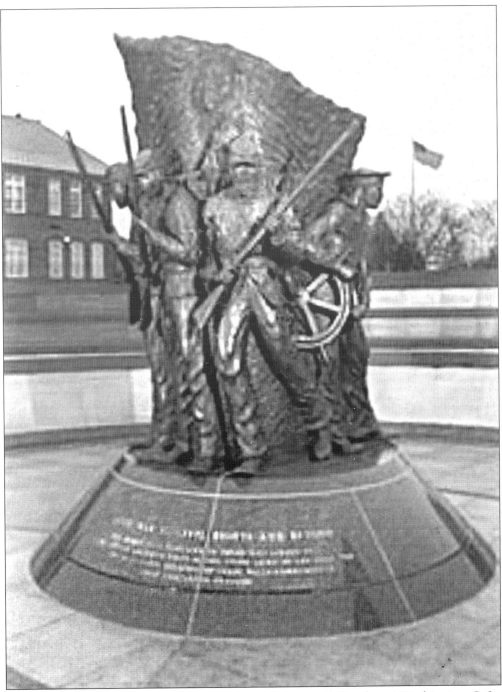

This *Spirit of Freedom* sculpture on Tenth and U Streets in Northwest Washington, D.C., wasn't unveiled until July 18, 1998, but it serves as an epitaph of the sacrifices made by African Americans during the Civil War. Kentucky artist Ed Hamilton sculpted the piece, which holds the distinction of being the first work by an African American to occupy federal land. The African American Civil War Museum opened the following year in 1999. (Courtesy African American Civil War Museum.)

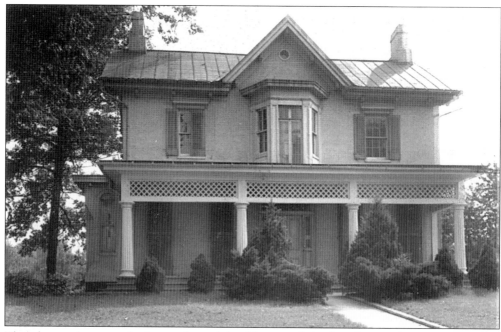

The above photograph shows the original home of Frederick Douglass in Anacostia. In 1877, Douglass purchased Cedar Hill. In 1895, Douglass died in his beloved hilltop home. Cedar Hill, located at 1411 W Street in Southeast, is now a historic landmark that is open to the public. (Scurlock Studios; Courtesy Smithsonian Institution.)

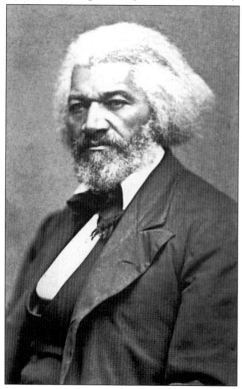

In 1958, Ben and Virginia Ali opened Ben's Chili Bowl on 1213 U Street, in the heart of the U Street corridor. Back then, U Street was known as Black Broadway. Over the years and still today, the atmosphere and secret chili recipe have drawn masses of high-profile celebrities, including Dr. Martin Luther King Jr., Ella Fitzgerald, Miles Davis, Cab Calloway, Dr. Bill Cosby, and Dr. Camille Cosby among others. Dr. Cosby and his wife, Dr. Camille Cosby, often visited the Chili Bowl during their courtship and today have still remained friends with the Ali family. (Courtesy Nizam Ali, Ben's Chili Bowl.)

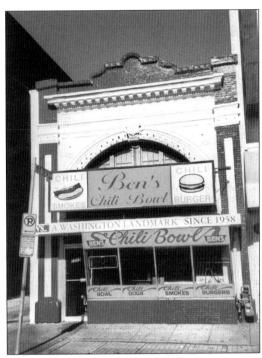

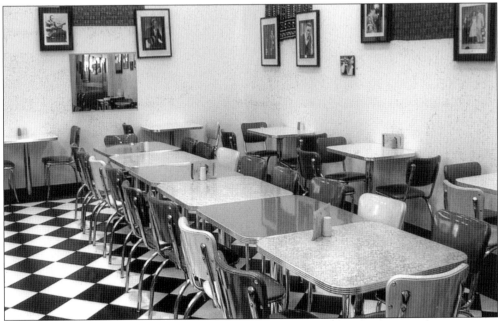

This photograph shows the interior of Ben's Chili Bowl restaurant. The walls are lined with photographs of the many celebrities and high-profile personalities who have visited the world-famous restaurant. In 2005, as part of an oral history project at the Library of Congress, Virginia Ali and her sons Kamal and Nizam Ali participated in an audio recording where they talked about Ben's Chili Bowl and their family history. That recording will live on in perpetuity for the public to enjoy in the archives of the Library of Congress. (Courtesy Nizam Ali, Ben's Chili Bowl.)

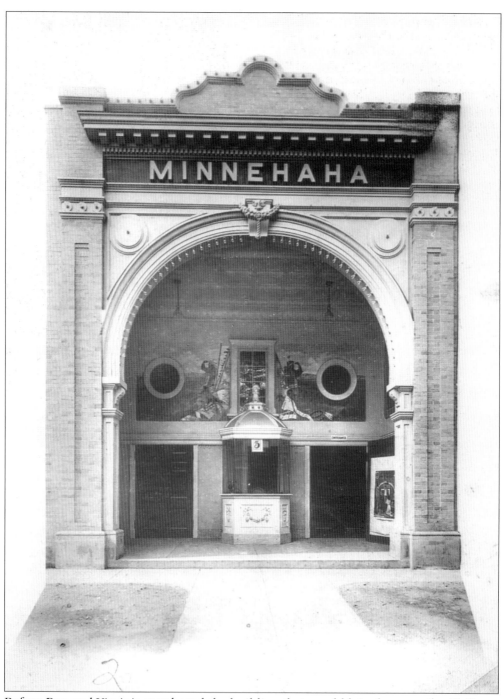

Before Ben and Virginia purchased the building that would later become the Chili Bowl, it was known as the Minnehaha Theater. The Minnehaha was one of the city's first African American theaters. It was a silent movie theater, or what is known as a nickelodeon theater or movie house, that charged an admission price of 5¢. (Courtesy Nizam Ali, Ben's Chili Bowl.)

This photograph shows Ben and Virginia Ali on their wedding day August 1958. Ben and Virginia came from very different backgrounds. He was a Muslim from Trinidad, and she was raised in a family of eight on a farm in Loretto, Virginia. She converted and became Muslim. They met when she was working as a teller at Industrial Bank. (Courtesy Nizam Ali, Ben's Chili Bowl.)

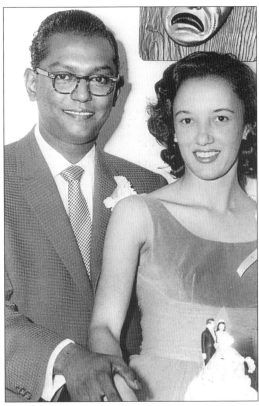

This portrait shows a young Ben Ali dressed in formal attire. In 2001, Ben and Virginia Ali were inducted into the D.C. Hall of Fame. (Courtesy Nizam Ali, Ben's Chili Bowl.)

As young women, Virginia Ali and her sister worked at Industrial Bank. (Courtesy Nizam Ali, Ben's Chili Bowl.)

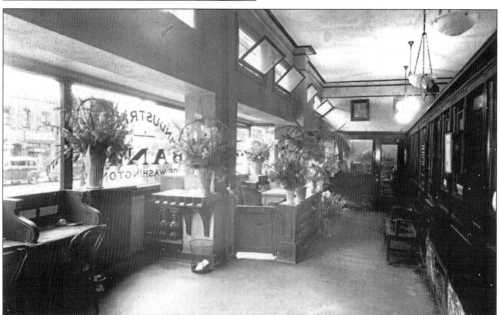

On May 1, 1913, Industrial Bank opened its doors at 11th and U Streets in Northwest Washington. At that time, Industrial Bank was the only black-owned bank in Washington. Today Industrial Bank is the second-largest black-owned financial institution in the country, boasting several hundred million dollars in assets. (Scurlock Studios; Courtesy Smithsonian Institution.)

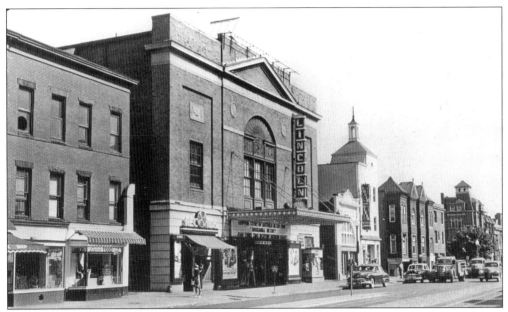

This is an early photograph of the Lincoln Theatre, which is located next door to Ben's Chili Bowl. The Lincoln Theatre and Ben's Chili Bowl are the cultural center of a vibrant U Street community. These institutions are the right and left chambers beating from the same heart. The Lincoln Theatre and Colonnade (hall where formal events were held) opened in 1922. It was not uncommon for celebrities such as Duke Ellington and Pearl Bailey (Washingtonians) to head over to Ben's Chili Bowl for a bite to eat following their performances at the Lincoln Theatre. Black owned businesses thrived on U street during the time of racial segregation but when the city de-segregated following a 1954 Supreme Court ruling businesses failed as African Americans began moving into other areas which were previously closed to them. The Lincoln Theatre closed in 1979, was remodeled and reopened in 1994. (Courtesy Nizam Ali, Ben's Chili Bowl.)

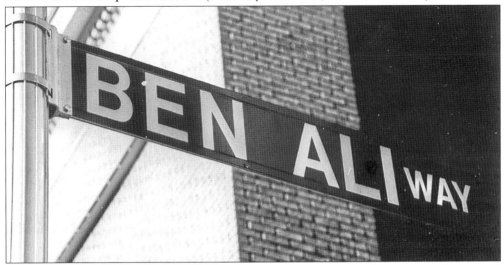

In 1980, the alley between Ben's Chili Bowl and the Lincoln Theatre was designated Ben Ali Way by Councilman Jim Graham because of Ben and Virginia Ali's restaurant and community involvement. (Courtesy Nizam Ali, Ben's Chili Bowl.)

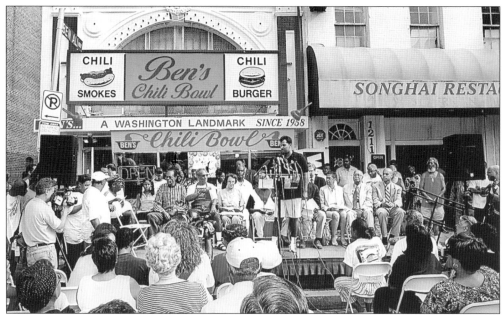

In 2003, Ben's Chili Bowl celebrated the restaurant's 40th anniversary with a street celebration. From left to right, D.C. councilmember and former mayor Marion Barry, entertainer Bill Cosby, Virginia Ali, Nizam Ali, Delegate Eleanor Holmes Norton, D.C. councilmember Adrian Fenty, and are featured in the photograph.

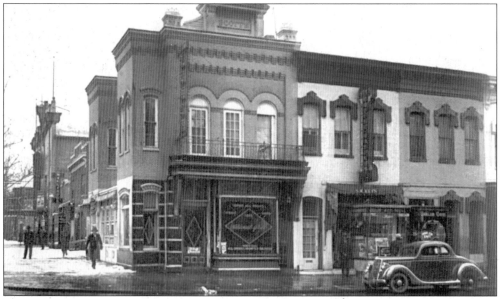

This photograph of the corner of Seventh and T Streets, NW, was taken in the winter of 1939. From left to right, the Scott's Building, which housed the National Grill, S. W. Keys, and Harlem Café are pictured. Around the corner, the Howard Theater can be seen. Vaudeville acts, films about African American music royalty, such as Duke Ellington, played inside the Howard Theater. Opened in 1910, the facility could accommodate more than 1,000 patrons until it closed its doors in 1910. (Scurlock Studios; Courtesy Smithsonian Institution.)

Four

WARTIME WASHINGTON

Clara Caroll, a clerical worker in the federal government, helps with the war effort in this photograph on January 15, 1943. (Courtesy National Archives.)

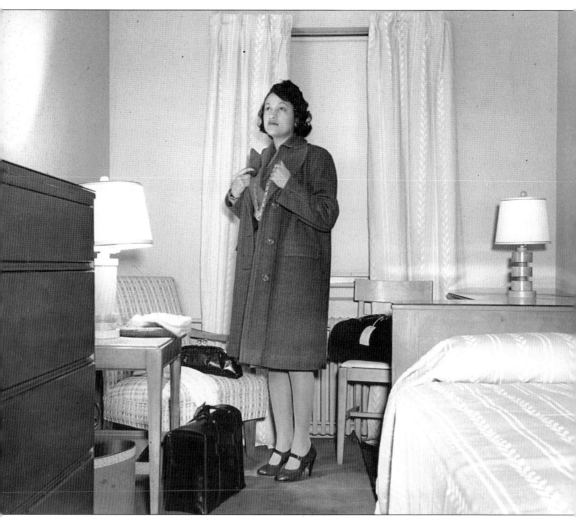

Clara Caroll was one of many people who relocated to Washington, D.C., to work for the government. Here she is inside her new home at the Lucy Slowe Residence Hall on January 15, 1943. Residence halls for government workers were segregated. (Courtesy National Archives.)

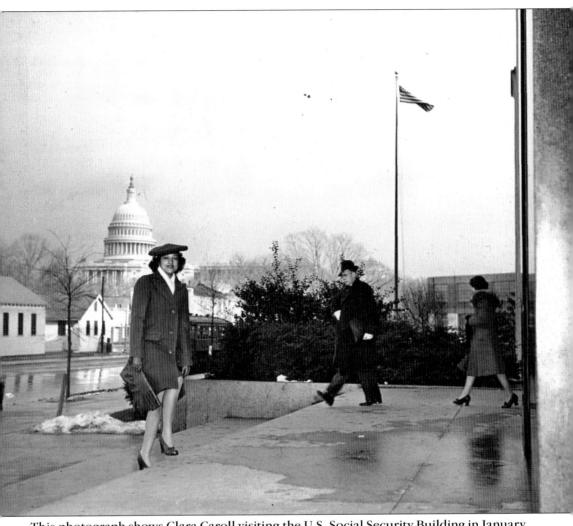

This photograph shows Clara Caroll visiting the U.S. Social Security Building in January 1943. (Courtesy National Archives.)

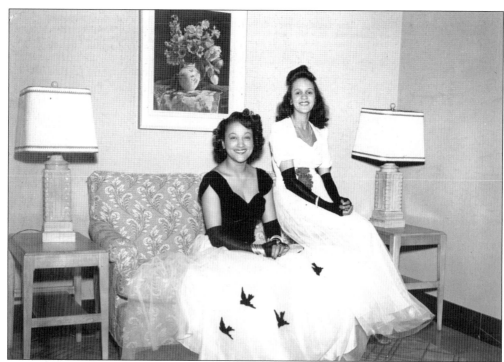

Clara Caroll and another government clerical worker, Dorothy Burgess, dressed for an event at the U.S. Social Security Building in January 1943. (Courtesy National Archives.)

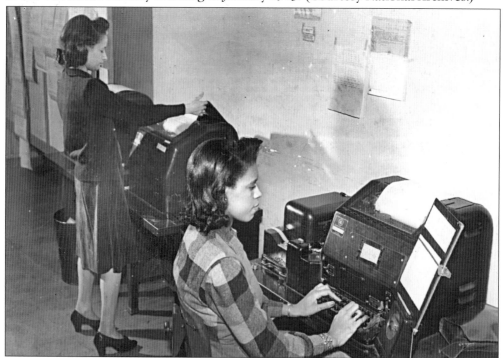

Two unidentified government clerical workers operate Teletype machines in this January 1943 photograph. (Courtesy National Archives.)

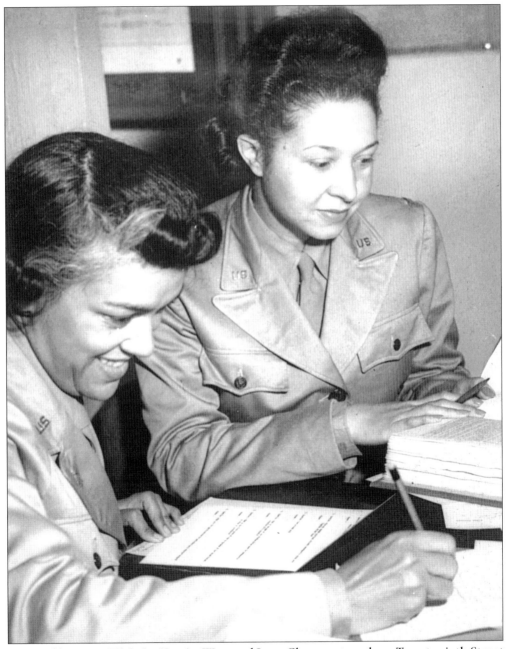

Pictured here are WACs Lt. Harriet West and Irma Clayton at work on Twenty-sixth Street
c. 1942. WAC is the acronym for the Women's Army Corps.

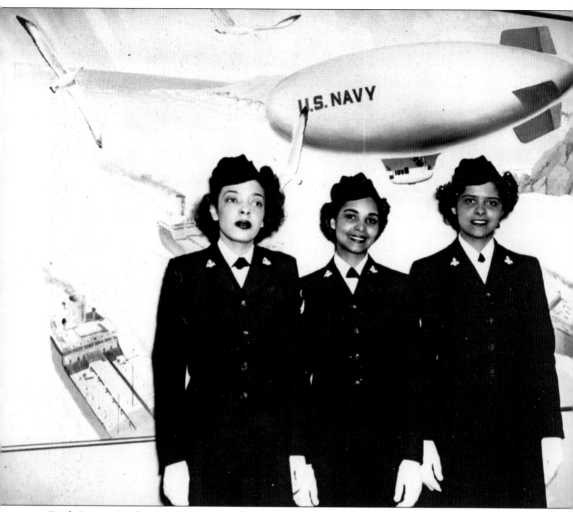

Ruth Isaacs, Katherine Horton, and Inez Patterson are the first African American hospital apprentices (WAVES) to enter the Hospital Corps at National Naval Medical Center in Bethesda, Maryland. (Courtesy National Archives.)

A church official welcomes cadet nurses on July 13, 1945. (Courtesy National Archives.)

LTJG Stanly Marlowe Smith, U.S. Maritime Service, is flanked by Marion H. Elliott, assistant executive secretary of the National Council of Negro Women, and Mrs. B. L. Derrick, chairman of the NCNW, during a war bond rally in Washington, D.C. LTJG Smith spoke and was honored at the ceremony, which was held on August 8, 1944. (Courtesy National Archives.)

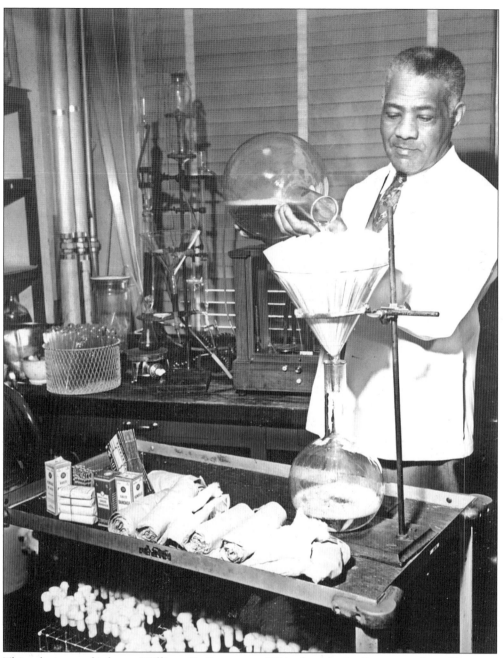

This photograph shows William R. Carter, an FDA pharmacist for more than 40 years, working in a laboratory. Carter's job involved testing the sterility of materials used for making bandages in the 1940s. (Courtesy National Archives.)

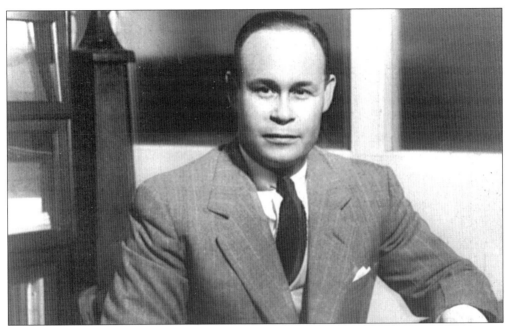

Dr. Charles Drew, a Washington surgeon and inventor of the blood bank, is shown here in a photograph taken at Howard University. Born in Washington, D.C., in 1904, Dr. Drew, a graduate of Amherst College, received his medical training from McGill University. Before going to Canada to attend medical school, Drew taught biology at Morgan State University. In 1935, he became an instructor of pathology at Howard University. He is the father of former D.C. Ward 4 councilmember Charlene Drew Jarvis. (Scurlock Studios; Courtesy Smithsonian Institution.)

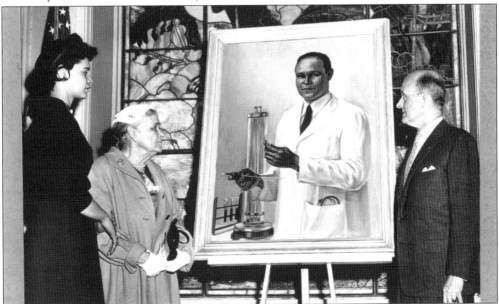

On May 10, 1959, this photograph was taken of Dr. Charles Drew's mother, Nora Burrell Drew, and his daughter, Charlene Drew, with Gen. Alfred Gruenther, president of the American Red Cross, as they observed a portrait of Dr. Charles Drew.

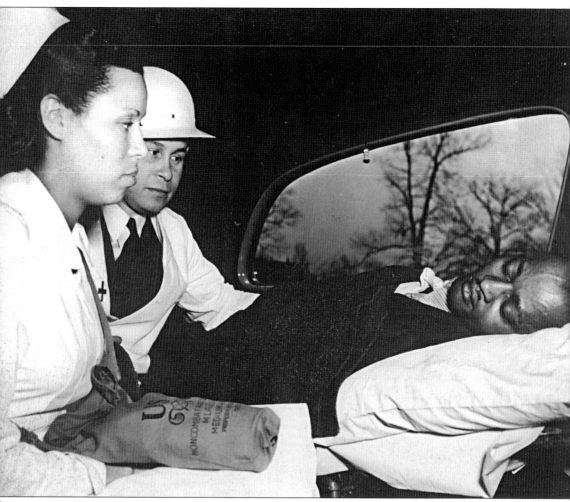

Dr. Charles Drew administers first-aid treatment during a practice air-raid drill. Air-raid drills were performed with some frequency in Washington. One document characterizes the air-raid drills happening as often as school fire drills. (Courtesy National Archives.)

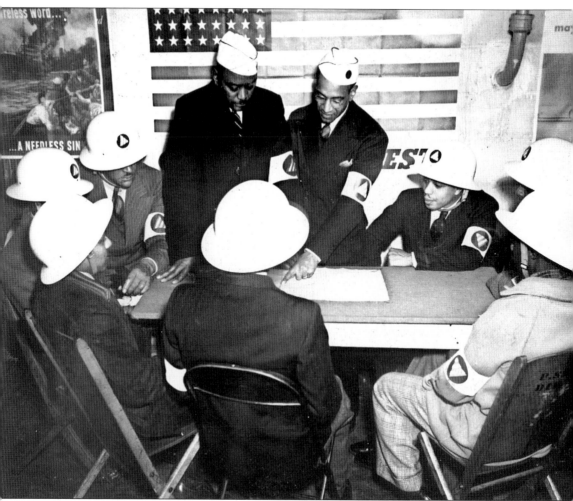

Air raid wardens are gathered here in 1942 for a sector meeting in Washington, D.C., to discuss strategy for a practice air raid. (Courtesy National Archives.)

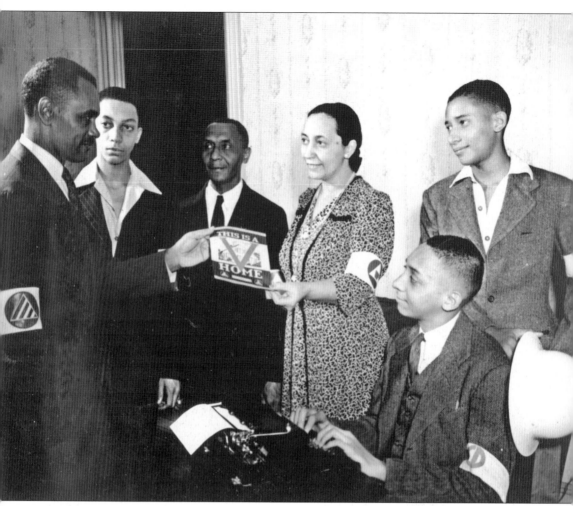

During World War II, civil defense officials awarded V-Home preparation station stickers to several qualified homes in 1942. The V-Home "We are Prepared" stickers were awarded if homes met conditions, including removal of combustibles and flammable material and having protective equipment on the premises in the event of an enemy attack. The campaign was national in scope. (Courtesy National Archives.)

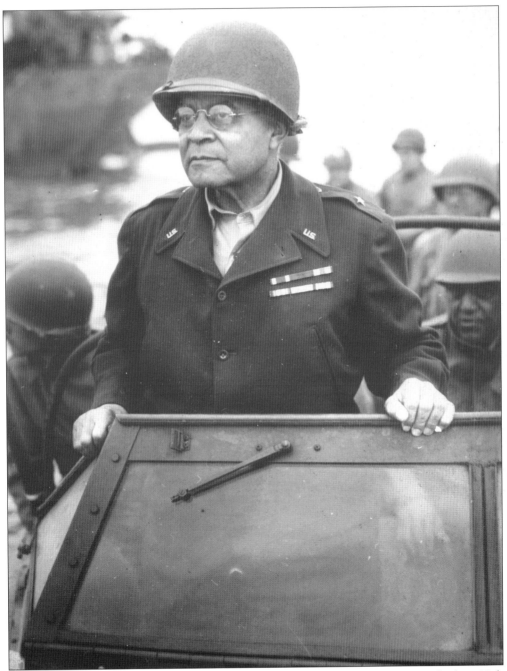

Washington, D.C.'s own native son Benjamin Oliver Davis Sr. was born in the late 19th century (his birth date is the subject of debate, either 1877 or 1880). Davis surmounted tremendous obstacles in the military, and despite discrimination, he became first African American to rise to the rank of general in the U.S. Army. Here Brig. Gen. Benjamin O. Davis Sr. observes a Signal Corps as the crew erects poles in France on August 8, 1944. (Courtesy National Archives.)

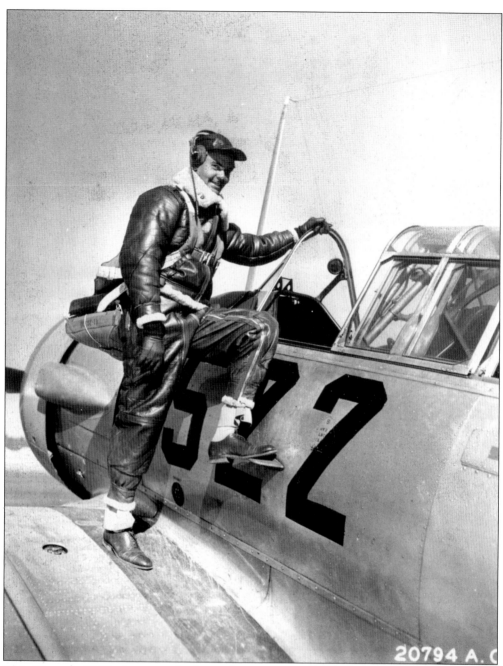

This January 1942 photograph shows Brig. Gen. Benjamin Oliver Davis's son, then Capt. Benjamin Oliver Davis Jr., of Washington, D.C., climbing into an advanced trainer in Tuskegee, Alabama. Following in his father's footsteps, Davis Jr. acquired the rank of general in the U.S. Air Force. Gen. Benjamin Oliver Davis Jr. was the first African American to rise to the rank of general for that branch of the military services. (Courtesy National Archives.)

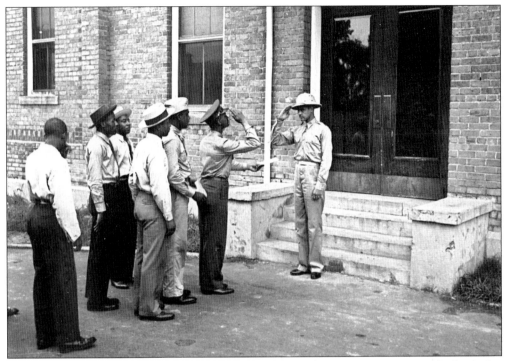

In September 1941, Army Air Corps cadets reported to Capt. Benjamin O. Davis Jr., commandant of cadets, at Tuskegee Field, Alabama. Davis Jr. led the Tuskegee Airmen during World War II. (Courtesy National Archives.)

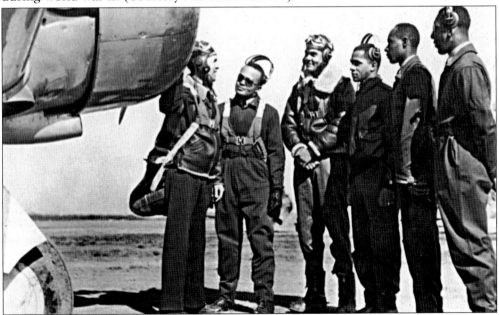

This 1942 photograph shows Capt. Benjamin O. Davis Jr. surrounded by the Tuskegee Airmen. In 1942, the Army Air Force opened a training post for black pilots at Tuskegee Institute. The exemplary group destroyed 400 enemy planes during the war. (Courtesy National Archives.)

The members of Cardozo High School's Victory Corps appear in this June 1943 photograph. Cardozo High School was located at 1300 Clifton Street, NW. (Courtesy National Archives.)

During World War II, students at Armstrong Technical High School made model airplanes for the United States. This photograph was taken in March 1942. Students who attended Armstrong Technical were exposed to industrial arts. (Courtesy National Archives.)

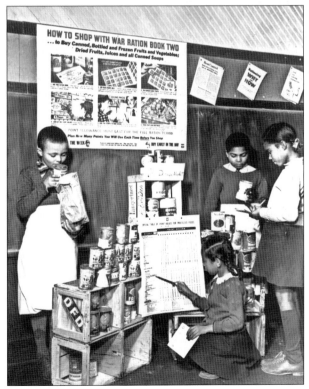

This World War II–era photograph shows a group of children learning how to shop with point stamps in a Fairfax County, Virginia, grade school. During this exercise, the children have set up a store with a point value table and information on the point rationing system. (Courtesy National Archives.)

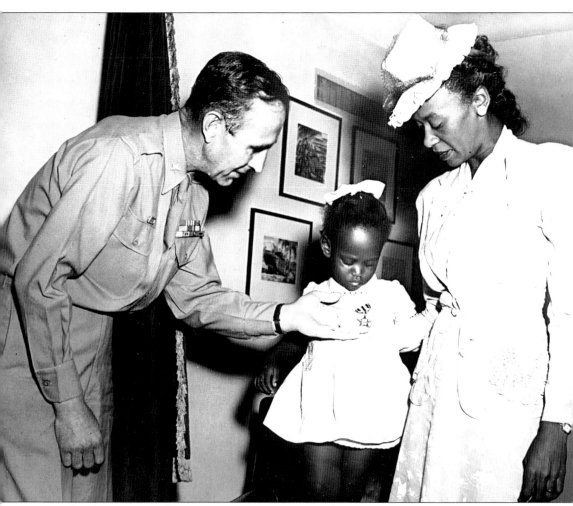

Two-year-old Melba Rose Madison stands by as her mother accepts a Silver Star in honor of Melba's deceased father. Brig. Gen. Robert Young, commanding general of the Military District of Washington, awards the medal to 1st Lt. John W. Madison's family after he was killed in Italy during combat. (Courtesy National Archives.)

Five

WASHINGTON LIFE
Everyday People

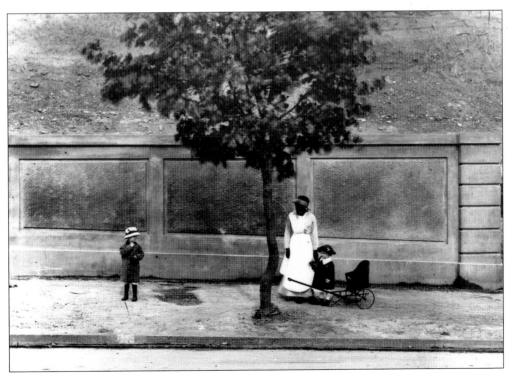

This 1910 photograph shows an African American nanny caring for two small children at Meridian Hill Park. In the early 20th century, more than 60 percent of African American women were employed as domestics. (Courtesy National Archives.)

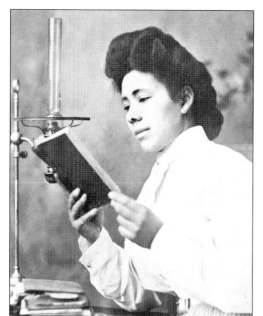 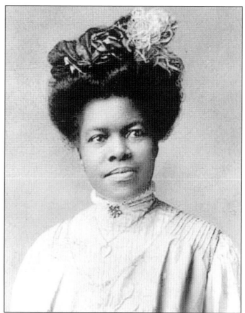

The woman shown reading in this photograph (left) is believed an associate or student of Nannie Helen Burroughs. This photograph was taken between 1900 and 1920. Nannie Helen Burroughs (right) aspired to become a teacher in the early 1900s, but the Washington, D.C., school board wouldn't allow her. So she founded her own school, the National Training School located on Fiftieth Street in Northeast Washington. The boarding school taught women the vocational skills needed to be successful personally and professionally. May 10 is Nannie Helen Burroughs Day in Washington, D.C. (Left, courtesy Library of Congress.)

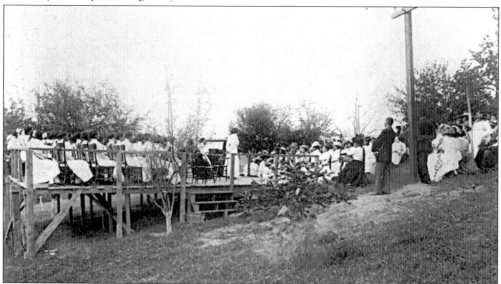

Initially Nannie Helen Burroughs's Training School for Girls had only 35 students. Following the schools opening in 1910, women graduated in ceremonies like this one after having mastered the curriculum, which included Burroughs's philosophy of religion, cleanliness, and domestic self-sufficiency. (Courtesy Library of Congress.)

A woman doing laundry in
a washtub appears in this
photograph, taken around 1909.
(Courtesy Library of Congress.)

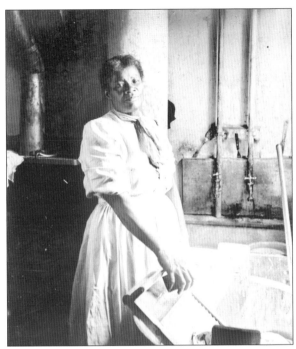

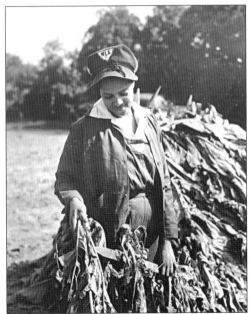

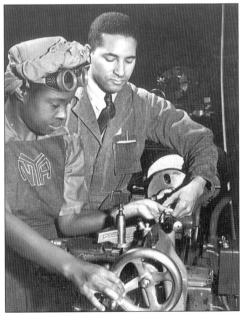

(*At left*) Farming tobacco is a stark contrast to city living. Not far from Washington, D.C.,
Mrs. Sam Crawford helps with tobacco harvesting on her husband's farm in Maryland.
In this photograph taken on October 8, 1943, Mrs. Crawford wears the Women's Land
Army uniform. (Courtesy National Archives.) (*At right*) Former domestic worker Juanita
Gray learns to operate a lathe machine as her supervisor, Cecil Coles, looks on. This
photograph was taken in the 1940s at the Washington, D.C., War Production and Training
Center. Hundreds of Negro women domestics were trained for machinery positions.
(Courtesy National Archives.)

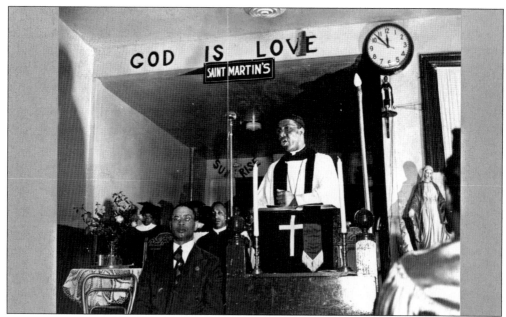

This August 1942 photograph shows Rev. Vondell Gassaway, pastor of the St. Martin's Spiritual Church, standing in a bowl of sacred water decorated with roses next to a statue of the Virgin Mary. The ritual is part of the annual flower bowl demonstration. Acclaimed photographer Gordon Parks took this photograph while documenting urban communities for the Farm Security Administration. (Gordon Parks photograph; Courtesy Library of Congress.)

A young Rev. Dr. Howard N. Stanton Sr. is pictured here. Born June 22, 1899, in Leesburg, Virginia, to French and Maggie Stanton, he attended Howard University in the early 20th century. Dr. Stanton transferred to Lincoln Jefferson University, where he received his Bachelor of Arts degree in 1920. He also earned a Bachelor of Theology degree from Miller Theological College in 1924 and a Doctorate of Philosophy degree in 1952 from Western University in San Diego, California. Dr. Stanton would return to Howard University as a member of the university's Saturday College faculty. He served as dean of religion for Howard University (Saturday College) and Luther Rice College. According to his family, Dr. Stanton was an avid "shutterbug" and documented the faces of hundreds of African Americans he encountered in Washington, D.C., and surrounding areas. Several of the photographs in this chapter, "Everyday People," are the associates, friends, and family of Dr. Stanton and date back as far as 1902. (Courtesy Valeria S. Henderson, Stanton family archives.)

This unidentified woman's photograph is estimated to have been taken in the 1920s in Leesburg, Virginia. The 1920s followed a period of racial animus in the nation, known as the Red Summer of 1919. Race riots broke out in urban cities around the country, including only a few miles away from Leesburg in Washington, D.C., Both blacks and whites were killed during the uprising. (Courtesy Valeria S. Henderson, Stanton family archives.)

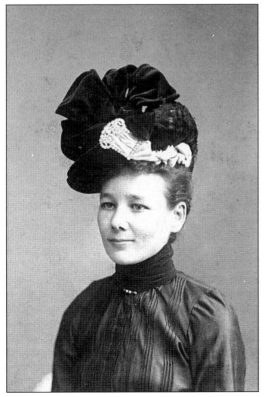

She is lovely and impeccably dressed, but even still, African American women like this one endured the humiliation of racial segregation. This unidentified woman's photograph comes from the Stanton family archives. She appears to be smiling, however, segregation in the city meant that this woman could not shop in the same retail establishments as her white cohorts; she could not use the same facilities, eat at certain restaurants, or live in the neighborhood of her choosing. (Courtesy Valeria S. Henderson, Stanton family archives.)

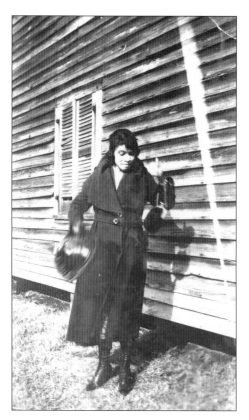

An unidentified nattily attired woman stands at the side of a house. The photograph dates from around the mid-1920s. Around that same period, in August 1925, activist A. Philip Randolph organized the Brotherhood of Sleeping Car Porters in Washington, D.C. (Courtesy Valeria S. Henderson, Stanton family archives.)

The unidentified man with the handlebar moustache sits on the front porch of a house with the landscape as a backdrop. The handlebar moustache was popular in the 1920s. (Courtesy Valeria S. Henderson, Stanton family archives.)

An unidentified young woman wearing bows in her hair posed for this photograph at a studio on Seventh Street in NW Washington, D.C. Students her age may have attended Shaw Junior High School, the first African American junior high school in the city. Established in 1902 and then located at Seventh and Rhode Island Avenues in Northwest, Shaw is named after Robert Gould Shaw, the white Civil War Commander of the African American 54th Union regiment. Shaw Junior High's new building is located at 925 Rhode Island Avenue, NW, and was constructed in 1977. (Courtesy Valeria S. Henderson, Stanton family archives.)

That same woman is photographed years later dressed in formal attire. She is believed to be a friend of the Stanton family. (Courtesy Valeria S. Henderson, Stanton family archives.)

An infant child dressed in a christening gown sits on a chair for this portrait. The unidentified infant is believed to be a relative of the Stanton family. (Courtesy Valeria S. Henderson, Stanton family archives.)

This unidentified associate of the Stanton family strikes a pose on a love seat wearing a hat and bow tie. Republic Gardens was a dinner club opened at 1355 U Street in the 1920s. African Americans could be seen there dressed in the finest attire enjoying entertainers like Charlie Parker, Duke Ellington, and Pearl Bailey. The Republic Gardens closed in 1960 but has since reopened. (Courtesy Valeria S. Henderson, Stanton family archives.)

According to the note on this photograph, the baby boy pictured here in his christening gown is named French. French Stanton was Dr. N. Howard Stanton's father. The photograph was taken in the 19th century. (Courtesy Valeria S. Henderson, Stanton family archives.)

The note on this historic photograph reads, "To Esther from Frances." Frances is the woman in the photograph; Esther is Dr. N. Howard Stanton's wife. They were married in 1926. Esther Gray was an educator and product of the Washington, D.C., and Alexandria school systems. The Stantons had seven children, two of which have active roles in preserving the history of African Americans in Alexandria. (Courtesy Valeria S. Henderson, Stanton family archives.)

This infant was likely born to people in the Stanton family social circle. The photograph is estimated to have been taken between 1900 and 1920. According to a 1999 Centers for Disease Control Morbidity report, in 1900, 30 percent of infants died before their first birthday in urban cities in the United States. (Courtesy Valeria S. Henderson, Stanton family archives.)

An unidentified gentleman dressed in a suit makes for a distinguished portrait around 1920. On November 3 of that year, Pres. Warren G. Harding, a Republican, was elected. (Courtesy Valeria S. Henderson, Stanton family archives.)

This 1920s photograph of an African American woman sitting with a backdrop of beach was believed to have been taken by Dr. N. Howard Stanton. His wife, Ester, was also very active in social organizations. She was a member of Israel Temple #138, Elks, the Flowers Club, and the Eastern Star of Alexandria, Virginia. A one-time teacher, Stanton retired from the federal government service in 1965 following 20 years of service. The woman pictured here may have been in Stanton's social circle. (Courtesy Valeria S. Henderson, Stanton family archives.)

This image depicts a young man in military uniform. By 1918, 400,000 African American men were fighting in World War I, half of them in France. Following their military service, many returned to face discrimination and hostility in the United States. (Courtesy Valeria S. Henderson, Stanton family archives.)

The Harlem Renaissance was in full swing around the time this gentleman's photograph was taken. The Renaissance featured the works of African American artists, writers, and musicians. In 1925, Howard philosophy professor Alaine Locke edited an anthology called *The New Negro*. He is credited with being one of the pioneers of the New Negro Movement—an artistic and cultural movement. Harvard- and Oxford-educated Locke was the first African American Rhodes Scholar. (Courtesy Valeria S. Henderson, Stanton family archives.)

A young man outfitted with a newsboy cap poses with a cigar in this portrait. (Courtesy Valeria S. Henderson, Stanton family archives.)

The gentleman seated for this portrait in a tweed suit is thought to be an acquaintance of Dr. N. Howard Stanton, the first African American to run for an Alexandria, Virginia, city council office. (Courtesy Valeria S. Henderson, Stanton family archives.)

This photograph of an unidentified little boy standing on a chair is believed to have been taken in the early 20th century. (Courtesy Valeria S. Henderson, Stanton family archives.)

The unidentified gentleman shown here poses in a suit carrying firewood. Dr. N. Howard Stanton is believed to be the photographer. In 1920, there were 53 documented lynchings of African Americans. (Courtesy Valeria S. Henderson, Stanton family archives.)

An unidentified Stanton family friend strikes a demure pose in a print dress standing at the side of a home, c. 1930s. In 1934, opera singer Lillian Evanti performed for Franklin D. Roosevelt at the White House. (Courtesy Valeria S. Henderson, Stanton family archives.)

This unidentified woman's photograph from the Stanton family archives was taken in the early 20th century. During this period, African American women around the country were buying hair care products manufactured by Madame C. J. Walker. Some of these women even became sales representatives. Madame Walker, born in 1867 in the Louisiana Delta, was one of the first self-made African American millionaires. In 1917, she organized a group of women in D.C. to protest the practice of segregation in the U.S. armed forces. She died in 1919. (Courtesy Valeria S. Henderson, Stanton family archives.)

This photograph of an infant child is estimated to have been taken between 1900 and 1920. The 2006 edition of the *World Almanac for Kids* shows that the population in the District increased a total of 250,000 between the years of 1920 and 1940. (Courtesy Valeria S. Henderson, Stanton family archives.)

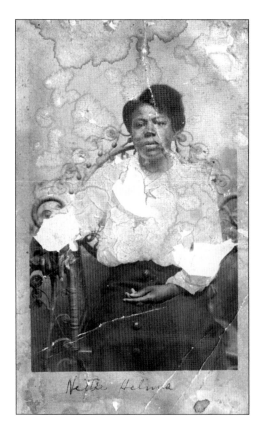

Nettie Helms sat for this vintage photograph in Leesburg, Virginia. Reverend Stanton's mother and father lived in Leesburg. He was born there in 1899. (Courtesy Valeria S. Henderson, Stanton family archives.)

An unidentified little girl in a dress stands on a bench as her photograph is taken c. 1920s. In Georgetown, African American children played at Rose Park Recreation Center located at 26th and O. Streets, NW. In the 1930s, a "coloreds only" sign raised the ire of members of the Rock Creek Park Civic Association. The sign was removed. (Courtesy Valeria S. Henderson, Stanton family archives.)

This photograph of a young woman identified only as "Sue" was given to Reverend Stanton's mother, Maggie. The photograph dates from between the late 19th to the early 20th century. (Courtesy Valeria S. Henderson, Stanton family archives.)

An unidentified gentleman poses on a park bench inside a photographer's studio for this *c.* 1920s photograph. (Courtesy Valeria S. Henderson, Stanton family archives.)

The A. J. Jameson studios in Alexandria photographed this unidentified young woman wearing a white dress in the 1920s. (Courtesy Valeria S. Henderson, Stanton family archives.)

The portrait of this unidentified woman was taken in 1902. She may have been a family member of Dr. N. Howard Stanton. He was born in 1899. Census figures show African Americans comprised 10 percent of the population in the United States in 1910. (Courtesy Valeria S. Henderson, Stanton family archives.)

An unidentified Stanton family associate sits in a rocking chair on a porch, *c.* 1920s. That year, the number African American farm owners in the United States reached an all-time high of nearly 160,000. (Courtesy Valeria S. Henderson, Stanton family archives.)

This unidentified child stands on a chair for her portrait. (Courtesy Valeria S. Henderson, Stanton family archives.)

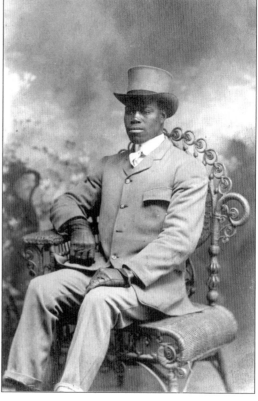

The photograph of this gentleman wearing a suit and top hat was believed to have been taken by Dr. N. Howard Stanton. The top hat was an accessory frequently donned by men in the 1920s. (Courtesy Valeria S. Henderson, Stanton family archives.)

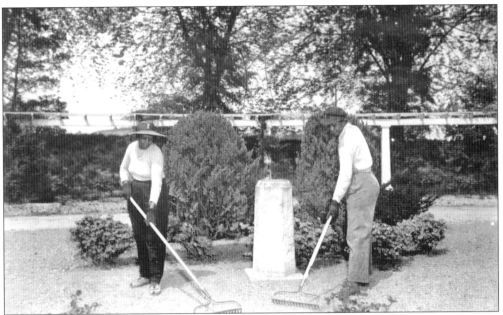

This 1940s image shows African American employees tilling the land at one of the most picturesque institutions in the city. The United States Botanic Gardens were established in the early 1800s during the administration of President James Monroe. (Courtesy National Archives.)

This image shows a worker maintaining the grounds at the United States Botanic Gardens in 1940. (Courtesy National Archives.)

"Baby Williams" is photographed seated on a chair in the early 20th century. Between 1900 and 1930, most babies were born at home using midwives and poor obstetrical practices, according to a Centers for Disease Control report. These conditions were responsible for a 40 percent maternal death rate and a high infant mortality rate. (Courtesy Valeria S. Henderson, Stanton family archives.)

This older gentleman is believed to have been an acquaintance of Dr. N. Howard Stanton. As a pastor of churches from Maryland, Dr. Stanton encountered members of his church congregations and people who participated in organizations and civic associations where Dr. Stanton held memberships. (Courtesy Valeria S. Henderson, Stanton family archives.)

This man dressed in a suit jacket and bow tie was also a Stanton family associate from the 1920s. (Courtesy Valeria S. Henderson, Stanton family archives.)

The note on the back of this pearl-clad woman's mid-1920s photograph reads, "To NHS from FJS." In 1926, Dr. Stanton was commissioned as a first lieutenant in the U.S. Army, where he served as a chaplain. (Courtesy Valeria S. Henderson, Stanton family archives.)

Two fashionably dressed women posed for this photograph, which probably was taken in the late 1920s or early 1930. The women are wearing wrapover coats. In the 1920s, fur around the collar accented many wrapover coats. (Courtesy Valeria S. Henderson, Stanton family archives.)

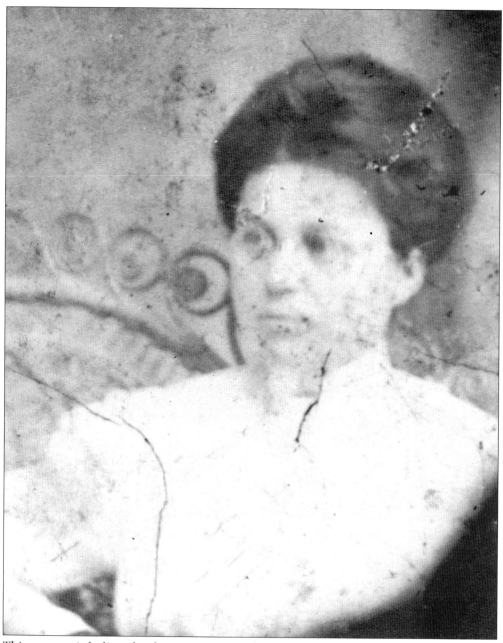

This woman is believed to be an associate of the Stanton family. The photograph likely dates from the 1920s. (Courtesy Valeria S. Henderson, Stanton family archives.)

An elderly woman poses in her front yard under a tree in the early 20th century. A 1999 Department of Health and Human Services report sets the life-expectancy rate for this time period at 47 years of age. One in 25 people survived life after 60. (Courtesy Valeria S. Henderson, Stanton family archives.)

It is estimated that this handsome young man's photograph was taken in the mid- to late 1920s. The photograph would have been taken around the same time that anti-lynching legislation was defeated in the U.S. Congress, *c.* 1922. (Courtesy Valeria S. Henderson, Stanton family archives.)

A gentleman, a Stanton family acquaintance, strikes an attractive pose in this photograph from the early 20th century. Manufacturing and industrial occupations are the primary occupations for African Americans in the North. (Courtesy Valeria S. Henderson, Stanton family archives.)

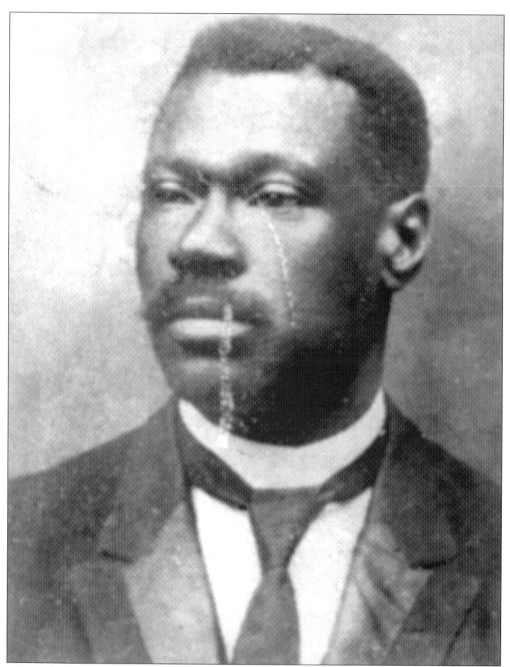

This man, an acquaintance of the Stanton family, may have participated in one of the organizations to which Dr. N. Howard Stanton Sr. devoted his time. Those organizations include the Olympic Boy's Club in Alexandria, the Elks Lodge #48, the Urban League, and the NAACP. Dr. Stanton was the past president of the local (Alexandria) NAACP. (Courtesy Stanton Family Archives.)

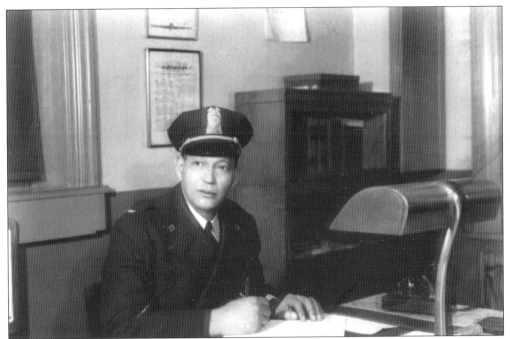

Police lieutenant Dan Pittman was the first African American officer in the Metropolitan Police Department. Lieutenant Pittman worked at the 13th precinct on Ninth and U Streets in Northwest Washington. (Scurlock Studios; Courtesy Smithsonian Institution.)

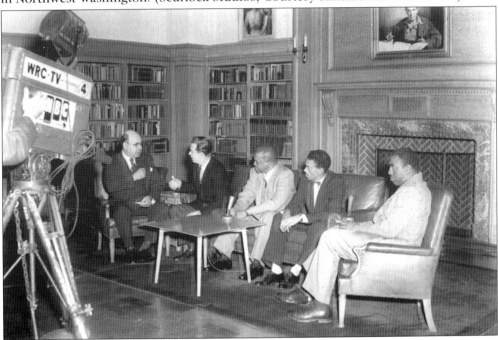

Hosts and guests participate in a televised program called the *Home Show*, which aired on WHUT, Howard University Television. WRC4, whose name is written on the camera, is the NBC-owned and operated station in Washington, D.C. (Scurlock Studios; Courtesy Smithsonian Institution.)

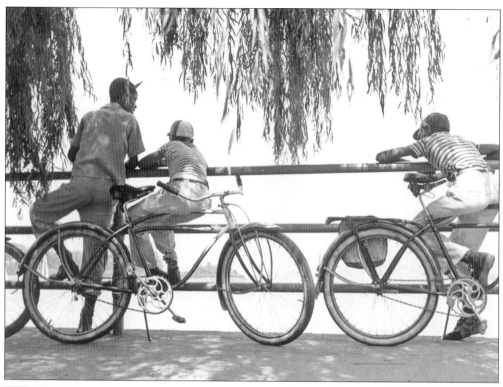

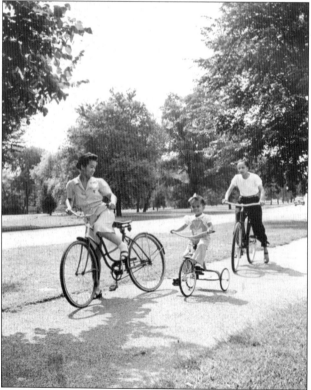

This 1950s photograph shows people relaxing by the river in East Potomac Park. At one time, fishing in the park was a popular pastime for Washingtonians. (Courtesy National Archives.)

Bike riding in Haines Point is another favorite pastime for people living in the city and surrounding areas. The photograph of this family was taken around the 1950s. (Courtesy National Archives.)

Six

NOTABLES

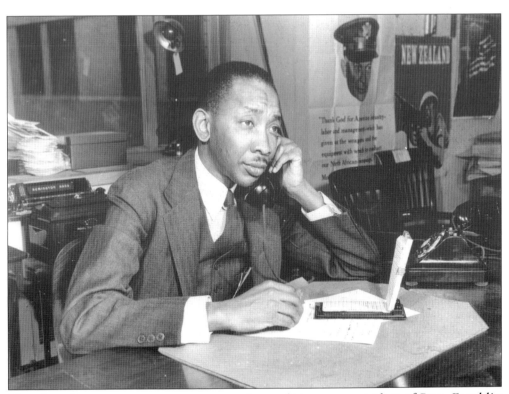

Theodore Poston, a veteran newspaper journalist, was a member of Pres. Franklin Roosevelt's 1940 advisory committee, the Black Cabinet. Poston lobbied for the hiring of more African American photographers as the head of the Negro News Desk in the Office of War Information. (Courtesy National Archives.)

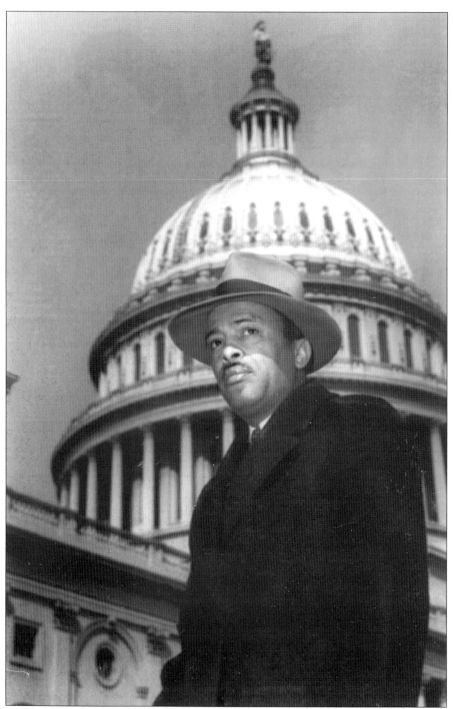

Reporter Louis Lautier is shown in this photograph with the U.S. Capitol in the background. This photograph was taken between 1950 and 1960. In 1947, Lautier was among a handful of African American journalists to receive credentials from the congressional press galleries and the Department of State. (Scurlock Studios; Courtesy Smithsonian Institution.)

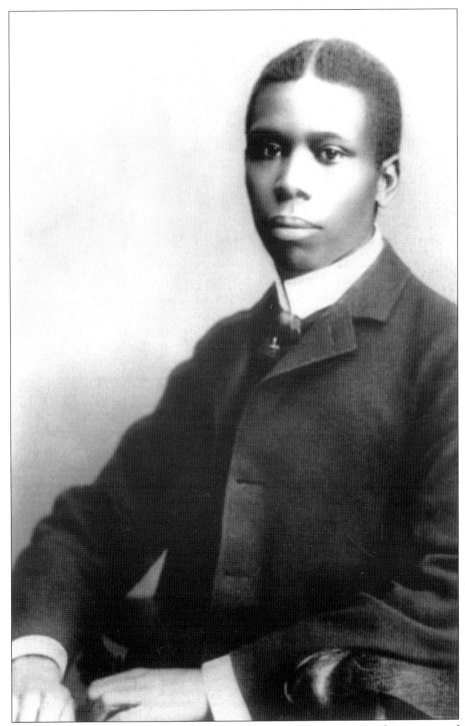

The son of former slaves, Paul Laurence Dunbar wrote prose that often mirrored the plight of the African American. Dunbar lived on U Street in Washington, D.C., beginning in 1897. Dunbar High School was later named in his honor. (Scurlock Studios; Courtesy Smithsonian Institution.)

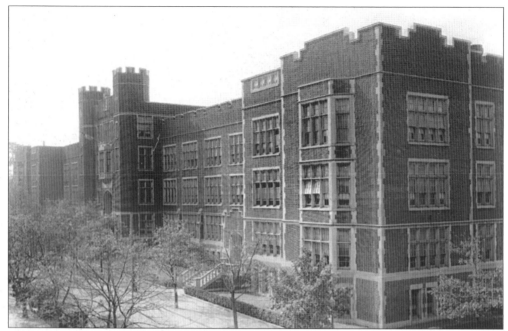

Paul Laurence Dunbar High School, formerly the M Street Preparatory school, was the first public high school for African Americans in the country. This photograph taken in the 1920s shows the exterior of the elite institution, which educated numerous public figures, including Nannie Helen Burroughs, Gen. Benjamin O. Davis Sr., Dr. Charles Drew, and Congresswoman Eleanor Holmes Norton (left). (Above; Scurlock Studios, Courtesy Smithsonian Institution.) (Delegate Holmes photograph; Courtesy United States House of Representatives.)

This photograph of Langston Hughes (center) was taken following a lecture at Howard University in 1957. Before being recognized as a literary giant, Hughes wrote poetry and supported himself by working a variety of positions in Washington, including busy boy, laundry attendant, and assistant to historian Carter G. Woodson. The financially challenged writer even lived for a short time at the YMCA on Twelfth Street. (Scurlock Studios; Courtesy Smithsonian Institution.)

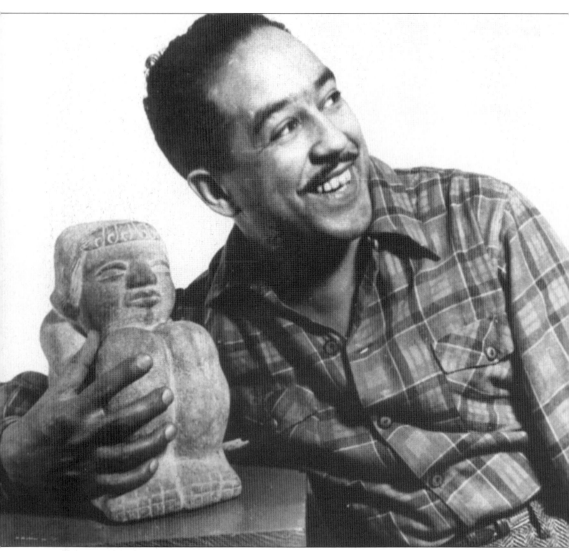

Langston Hughes is credited with being part of the Harlem Renaissance. The Harlem Renaissance was an era during the 1920s and ending in the 1930s in Harlem where African American writers, artists, and intellectuals participated in a cultural awakening. (Courtesy Library of Congress.)

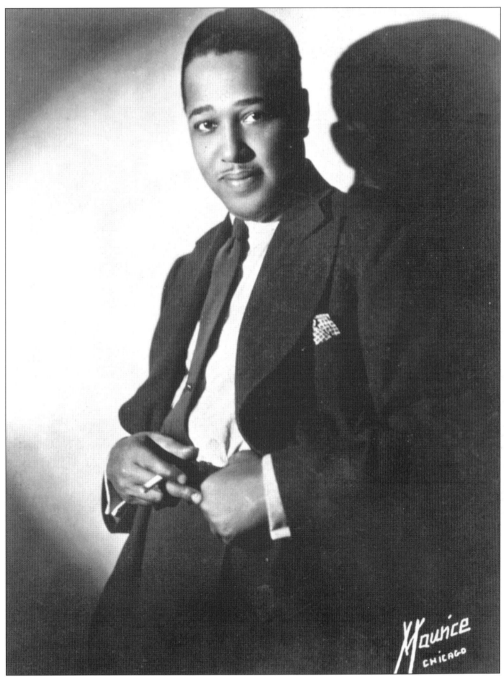

This photograph depicts a young Duke Ellington. Edward Kennedy Ellington ("Duke") was born on April 29, 1899, in Washington. He was educated at Armstrong Manual Training School but discontinued his education to pursue a career in music. During Ellington's career, he performed in cities around the world from Cairo, Egypt, to London, England. He is recognized as a significant figure in the landscape of American music with particular emphasis on the genre of jazz. Duke Ellington died in 1974. (Courtesy Michael Ochs Archives.)

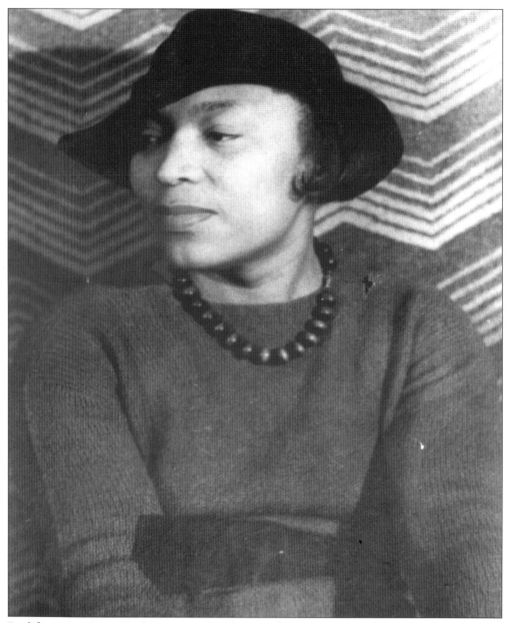

Prolific writer Zora Neale Hurston lived in Washington, D.C., while attending Howard University. Her works include *Mules and Men* and *Their Eyes Were Watching God*. (Courtesy New York Public Library's Schomburg Collection.)

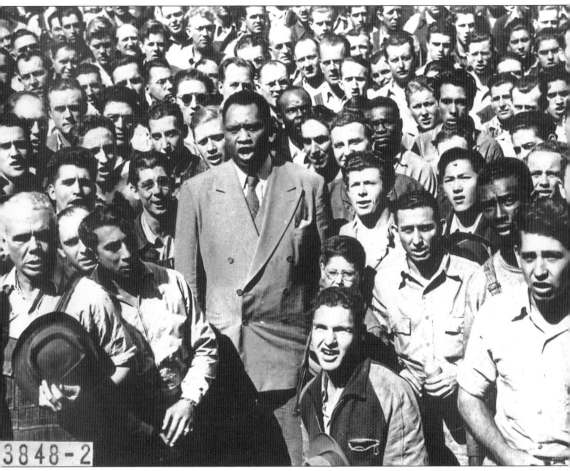

3848-2

Paul Robeson, a world-renowned baritone singer, activist, and former World War I shipyard worker, is pictured here singing with Moore Shipyard workers in Oakland, California, in September 1942. On this date, the group sang "The Star Spangled Banner" with Robeson. Earlier that same year, in May 1942, Robeson performed in Washington, D.C., at a Russian Embassy. Paul Robeson's brother, Dr. William Drew Robeson, lived in Washington, D.C. (Courtesy National Archives.)

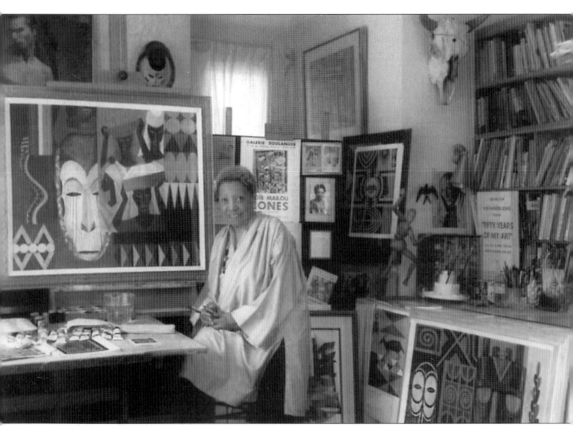

Artist and Howard University professor Lois Maelou Jones is seated surrounded by her artwork c. 1935–1937. Jones, who won international recognition as a textile designer, lived on Quincy Street in Brooklyn, located in Northeast Washington. Her career as a Howard University professor spanned 50 years. (Scurlock Studios; Courtesy Smithsonian Institution.)

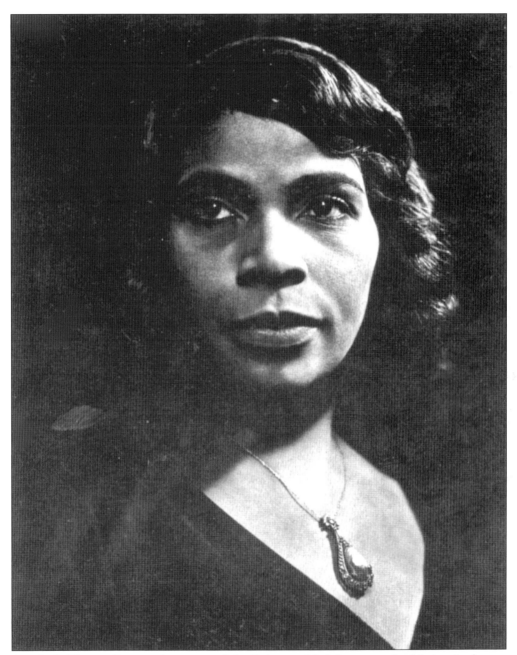

First Lady Eleanor Roosevelt presented the Spingarn Medal to contralto Marian Anderson in Richmond, Virginia, c. 1939. That same year, Anderson was denied the opportunity to perform at Constitution Hall for the DAR (Daughters of the American Revolution) because of her race. Constitution Hall's white performers–only contract clause incensed Eleanor Roosevelt so much that she ended her affiliation with the DAR. Roosevelt then gave Anderson a concert at the Lincoln Memorial. (Courtesy Moorland Spingarn Research Center.)

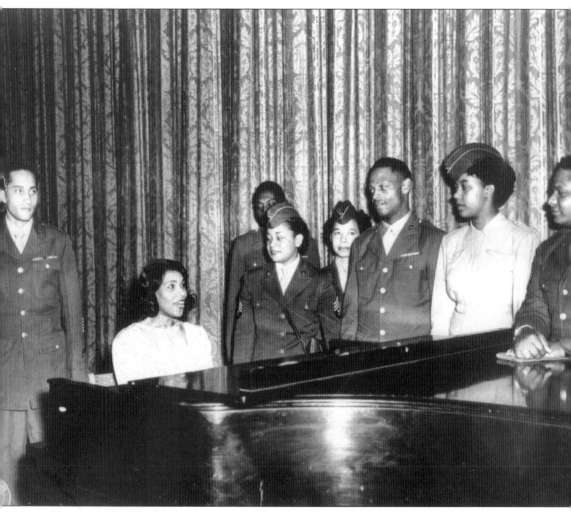

Singer Marian Anderson appears in this World War II–era photograph entertaining a group of service members who had served overseas on the stage of the San Antonio Municipal Auditorium. (Courtesy National Archives.)

She was born Lillian Evans in Washington, D.C., but the world would come to know her as the great soprano opera singer, Madam Lillian Evanti (Lilian Evans Tibbs). Evanti, a pioneer in her field and the first African American woman to perform abroad with an opera company, graduated from Howard University's School of Music in 1917. (Scurlock Studios; Courtesy Smithsonian Institution.)

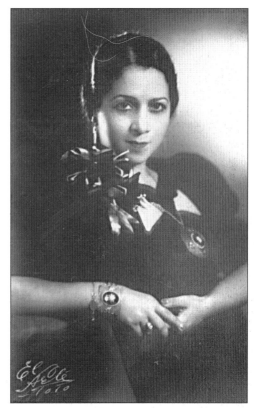

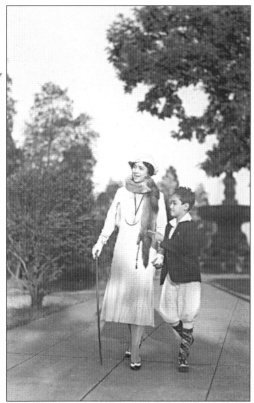

This photograph shows Madame Evanti on a stroll through the park with her son.

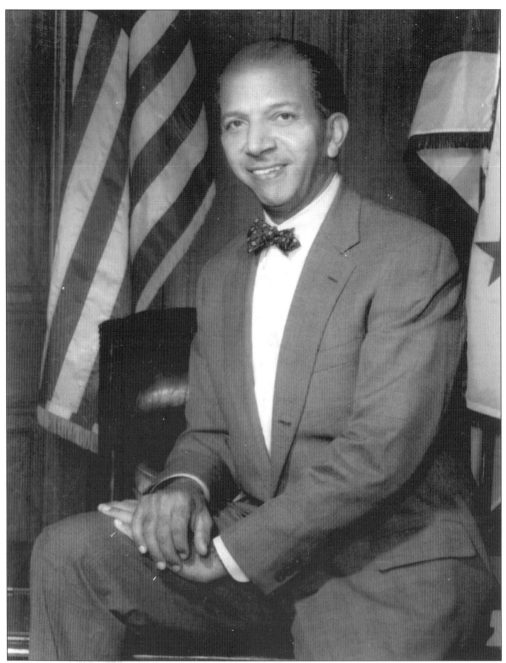

The District of Columbia's native son Mayor Anthony Williams will perhaps best be remembered for breathing life back into a city plagued with social, economic, and political problems. Adopted as a baby by Washingtonian Virginia Williams, Anthony Williams is a product of the District of Columbia school system. Mayor Anthony Williams is also among the distinguished parishioners of St. Augustine Catholic Church, located at Fifteenth and V Streets, NW. In 1858, St. Augustine's was founded by free African Americans. One of Williams's memorable accomplishments is bringing the Nationals baseball franchise to the city.

BIBLIOGRAPHY

Bennett, Lerone. *Before the Mayflower.* Chicago: Johnson Publishing Company, 1982.

District of Columbia Office of Cultural Tourism. *African American Heritage Trail Guide.* Washington, D.C.: Office of Cultural Tourism, 2003.

Lesko, Kathleen M., Valerie Melissa Babb, and Carroll R. Gibbs. *Black Georgetown Remembered: A History of its Black Community from the Founding of "The Town of George" in 1751 to the Present Day.* Washington, D.C.: Georgetown University Press, 1991.

Low, W. August and Virgil A. Clift. *Encyclopedia of Black America.* New York: Da Capo Press, 1984.

Poloski, Harry A. and Warren Marr. *The Negro Almanac.* New York: Bellwether Company, 1976.

Smith, Kathryn Schneider. *Port Town to Urban Neighborhood: the Georgetown Waterfront of Washington, D.C., 1880–1920.* Dubuque, IA: Kendall/Hunt, 1989.

Some, Sobonfu and Malidom Some. "From Whence We Came." *Essence.* 1999.

Wright, Kai. *Soldiers of Freedom: An Illustrated History of African Americans in the Armed Forces.* New York: Black Dog and Leventhal, 2002.

This photograph of the U.S. Capitol was taken in 1919. Until the mid-1800s, several hundred slaves helped with the construction of the Capitol. The slaves labored in cooperation with whites and free blacks. In 2006, a Congressional task force organized by Georgia congressman John Lewis reviewed ways to best honor the slaves and their significant contribution. (Courtesy Library of Congress.)

ACROSS AMERICA, PEOPLE ARE DISCOVERING SOMETHING WONDERFUL. *THEIR HERITAGE.*

Arcadia Publishing is the leading local history publisher in the United States. With more than 3,000 titles in print and hundreds of new titles released every year, Arcadia has extensive specialized experience chronicling the history of communities and celebrating America's hidden stories, bringing to life the people, places, and events from the past. To discover the history of other communities across the nation, please visit:

www.arcadiapublishing.com

Customized search tools allow you to find regional history books about the town where you grew up, the cities where your friends and family live, the town where your parents met, or even that retirement spot you've been dreaming about.